Praise for bell hooks's
all about love

"It is a warm affirmation that love is possible and an attack on the culture of narcissism and selfishness."

—*New York Times Book Review*

"A gracefully written volume . . . her treatise offers a deeply personal and—in this age of chicken-soupy psychobabble—unabashedly honest view of relationships." —*Entertainment Weekly*

"Her vision seems idealistic . . . ambitious. Yet it touches a yearning we all have and is expressed so sincerely. . . . hooks's *New Visions* reminds us that we can be a part of a loving community."

—*Philadelphia Inquirer*

"Pay attention to bell hooks. The American writer and cultural critic is becoming a household word . . . hooks's writing typically inspires, enlightens and provokes. She is an academic wild card, the brilliant feminist whose sharp mind can slice the latest scholarly shibboleth."

—*Boston Globe and Mail*

"She provides a refreshing spiritual treatise that steps outside the confines of the intellect and into the wilds of the heart."

—*Seattle Weekly*

"Every page offers useful nuggets of wisdom to aid the reader in overcoming the fears of total intimacy and of loss. . . . hooks's view of amour is ultimately a pleasing, upbeat alternative to the slew of books that proclaim the demise of love in our cynical time."

—*Publishers Weekly*

"A spiritual handbook, weighty with platitudes, yet refreshed with some thoughtful analyses that offer seekers a way to explore love's meaning, or meaningless." —*Kirkus Reviews*

"*All About Love: New Visions* promises to be one of the most engaging, life-affirming reads of the year. Come to it with an open mind, and an open heart, and prepare to be transformed."

—*Black Issues Book Review*

"Like love, this book is worth the commitment." —*Toronto Sun*

ALL ABOUT LOVE

NEW VISIONS

bell hooks

WILLIAM MORROW
An Imprint of HarperCollins*Publishers*

HarperCollins books may be purchased for educational, business, or sales promotional use. For information, please e-mail the Special Markets Department at SPsales@harpercollins.com.

A hardcover edition of this book was published in 2000 by William Morrow and Company, Inc.

FIRST HARPER PERENNIAL PAPERBACK EDITION PUBLISHED 2001.
FIRST WILLIAM MORROW PAPERBACK EDITION PUBLISHED 2018.

Designed by Jo Anne Metsch

The Library of Congress has catalogued the harcover edition as follows:

Hooks, Bell.
All about love : new visions / Bell Hooks
p. cm.
ISBN 0-688-16844-2
1. Love. 2. Feminist ethics I. Title.
BF575.L8 H655 2000 99-35253
306.7—dc21 CIP

ISBN 978-0-06-095947-0 (pbk.)

18 19 20 21 22 LSC 10 9 8 7 6 5 4 3 2 1

the first love letter i ever wrote was sent to you. just as this book was written to talk to you. anthony— you have been my most intimate listener. i will love you always.

in the song of solomon there is this passage that reads: "i found him whom my soul loves. i held him and would not let him go." to holding on, to knowing again that moment of rapture, of recognition where we can face one another as we really are, stripped of artifice and pretense, naked and not ashamed.

Contents

CONTENTS

Preface

WHEN I WAS a child, it was clear to me that life was not worth living if we did not know love. I wish I could testify that I came to this awareness because of the love I felt in my life. But it was love's absence that let me know how much love mattered. I was my father's first daughter. At the moment of my birth, I was looked upon with loving kindness, cherished and made to feel wanted on this earth and in my home. To this day I cannot remember when that feeling of being loved left me. I just know that one day I was no longer precious. Those who had initially loved me well turned away. The absence of their recognition and regard pierced my heart and left me with a feeling of brokenheartedness so profound I was spellbound.

Grief and sadness overwhelmed me. I did not know what I had done wrong. And nothing I tried made it right.

No other connection healed the hurt of that first abandonment, that first banishment from love's paradise. For years I lived my life suspended, trapped by the past, unable to move into the future. Like every wounded child I just wanted to turn back time and be in that paradise again, in that moment of remembered rapture where I felt loved, where I felt a sense of belonging.

We can never go back. I know that now. We can go forward. We can find the love our hearts long for, but not until we let go grief about the love we lost long ago, when we were little and had no voice to speak the heart's longing. All the years of my life I thought I was searching for love I found, retrospectively, to be years where I was simply trying to recover what had been lost, to return to the first home, to get back the rapture of first love. I was not really ready to love or be loved in the present. I was still mourning—clinging to the broken heart of girlhood, to broken connections. When that mourning ceased I was able to love again.

I awakened from my trance state and was stunned to find the world I was living in, the world of the present, was no longer a world open to love. And I noticed that all around me I heard testimony that lovelessness had become the order of the day. I feel our nation's turning away from love as intensely as I felt love's abandonment in my girlhood. Turning away we risk moving into a wilderness

of spirit so intense we may never find our way home again. I write of love to bear witness both to the danger in this movement, and to call for a return to love. Redeemed and restored, love returns us to the promise of everlasting life. When we love we can let our hearts speak.

GRACE:

TOUCHED BY LOVE

It is possible to speak with our heart directly. Most ancient cultures know this. We can actually converse with our heart as if it were a good friend. In modern life we have become so busy with our daily affairs and thoughts that we have lost this essential art of taking time to converse with our heart.

—JACK KORNFIELD

ON MY KITCHEN wall hang four snapshots of graffiti art I first saw on construction walls as I walked to my teaching job at Yale University years ago. The declaration, "The search for love continues even in the face of great odds," was painted in bright colors. At the time, recently separated from a partner of almost fifteen years, I was often overwhelmed by grief so profound it seemed as though an immense sea of pain was washing my heart and soul away. Overcome by sensations of being pulled underwater, drowning, I was constantly searching for anchors to keep me afloat, to pull me back safely to the shore. The declaration on the construction walls with its childlike drawing of unidentifiable animals always lifted my spirits. Whenever I passed this site, the affirmation of love's possibility sprawling across the block gave me hope.

Signed with the first name of local artist, these works spoke to my heart. Reading them I felt certain the artist

was undergoing a crisis in his life, either already confronting loss or facing the possibility of loss. In my head I engaged in imaginary conversations about the meaning of love with him. I told him how his playful graffiti art anchored me and helped restore my faith in love. I talked about the way this declaration with its promise of a love waiting to be found, a love I could still hope for, lifted me out of the abyss I had fallen into. My grief was a heavy, despairing sadness caused by parting from a companion of many years but, more important, it was a despair rooted in the fear that love did not exist, could not be found. And even if it were lurking somewhere, I might never know it in my lifetime. It had become hard for me to continue to believe in love's promise when everywhere I turned the enchantment of power or the terror of fear overshadowed the will to love.

One day on my way to work, looking forward to the day's meditation on love that the sight of the graffiti art engendered, I was stunned to find that the construction company had painted over the picture with a white paint so glaringly bright it was possible to see faint traces of the original art underneath. Upset that what had now become a ritual affirmation of love's grace was no longer there to welcome me, I told everyone of my disappointment. Finally someone passed on the rumor that the graffiti art had been whitewashed because the words were a reference to individuals living with HIV and that the

artist might be gay. Perhaps. It is just as likely that the men who splashed paint on the wall were threatened by this public confessing of a longing for love—a longing so intense it could not only be spoken but was deliberately searched for.

After much searching I located the artist and talked with him face-to-face about the meaning of love. We spoke about the way public art can be a vehicle for the sharing of life-affirming thoughts. And we both expressed our grief and annoyance that the construction company had so callously covered up a powerful message about love. To remind me of the construction walls, he gave me snapshots of the graffiti art. From the time we met, everywhere I have lived I have placed these snapshots above my kitchen sink. Every day, when I drink water or take a dish from the cupboard, I stand before this reminder that we yearn for love—that we seek it—even when we lack hope that it really can be found.

THERE ARE NOT many public discussions of love in our culture right now. At best, popular culture is the one domain in which our longing for love is talked about. Movies, music, magazines, and books are the place where we turn to hear our yearnings for love expressed. Yet the talk is not the life-affirming discourse of the sixties and seventies, which urged us to believe "All you need is love." Nowadays the most popular messages are those that de-

clare the meaningless of love, its irrelevance. A glaring example of this cultural shift was the tremendous popularity of Tina Turner's song with the title boldly declaring, "What's Love Got to Do with It." I was saddened and appalled when I interviewed a well-known female rapper at least twenty years my junior who, when asked about love, responded with biting sarcasm, "Love, what's that— I have never had any love in my life."

Youth culture today is cynical about love. And that cynicism has come from their pervasive feeling that love cannot be found. Expressing this concern in *When All You've Ever Wanted Isn't Enough,* Harold Kushner writes: "I am afraid that we may be raising a generation of young people who will grow up afraid to love, afraid to give themselves completely to another person, because they will have seen how much it hurts to take the risk of loving and have it not work out. I am afraid that they will grow up looking for intimacy without risk, for pleasure without significant emotional investment. They will be so fearful of the pain of disappointment that they will forgo the possibilities of love and joy." Young people are cynical about love. Ultimately, cynicism is the great mask of the disappointed and betrayed heart.

When I travel around the nation giving lectures about ending racism and sexism, audiences, especially young listeners, become agitated when I speak about the place of

love in any movement for social justice. Indeed, all the great movements for social justice in our society have strongly emphasized a love ethic. Yet young listeners remain reluctant to embrace the idea of love as a transformative force. To them, love is for the naive, the weak, the hopelessly romantic. Their attitude is mirrored in the grown-ups they turn to for explanations. As spokesperson for a disillusioned generation, Elizabeth Wurtzel asserts in *Bitch: In Praise of Difficult Women:* "None of us are getting better at loving: we are getting more scared of it. We were not given good skills to begin with, and the choices we make have tended only to reinforce our sense that it is hopeless and useless." Her words echo all that I hear an older generation say about love.

When I talked of love with my generation, I found it made everyone nervous or scared, especially when I spoke about not feeling loved enough. On several occasions as I talked about love with friends, I was told I should consider seeing a therapist. I understood that a few friends were simply weary of my bringing up the topic of love and felt that if I saw a therapist it would give them a break. But most folks were just frightened of what might be revealed in any exploration of the meaning of love in our lives.

Yet whenever a single woman over forty brings up the topic of love, again and again the assumption, rooted in

sexist thinking, is that she is "desperate" for a man. No one thinks she is simply passionately intellectually interested in the subject matter. No one thinks she is rigorously engaged in a philosophical undertaking wherein she is endeavoring to understand the metaphysical meaning of love in everyday life. No, she is just seen as on the road to "fatal attraction."

Disappointment and a pervasive feeling of brokenheartedness led me to begin thinking more deeply about the meaning of love in our culture. My longing to find love did not make me lose my sense of reason or perspective; it gave me the incentive to think more, to talk about love, and to study popular and more serious writing on the subject. As I pored over nonfiction books on the subject of love, I was surprised to find that the vast majority of the "revered" books, ones used as reference works and even those popular as self-help books, have been written by men. All my life I have thought of love as primarily a topic women contemplate with greater intensity and vigor than anybody else on the planet. I still hold this belief even though visionary female thinking on the subject has yet to be taken as seriously as the thoughts and writings of men. Men theorize about love, but women are more often love's practitioners. Most men feel that they receive love and therefore know what it feels like to be loved; women often feel we are in a constant state of yearning, wanting love but not receiving it.

In philosopher Jacob Needleman's primer *A Little Book About Love,* virtually all the major narratives of love he comments on are written by men. His list of significant references doesn't include books written by women. Throughout my graduate school training for a doctorate in literature, I can recall only one woman poet being extolled as a high priestess of love—Elizabeth Barrett Browning. She was, however, considered a minor poet. Yet even the most nonliterary student among us knew the opening line of her most well-known sonnet: "How do I love thee? Let me count the ways." This was in pre-feminist days. In the wake of the contemporary feminist movement, the Greek poet Sappho has now become enshrined as another love goddess.

Back then, in every creative writing course the poets dedicated to the love poem were always male. Indeed, the partner I left after many years first courted me with a love poem. He had always been emotionally unavailable and not at all interested in love as either a topic for discussion or a daily life practice, but he was absolutely confident that he had something meaningful to say on the subject. I, on the other hand, thought all my grown-up attempts to write love poems were mushy and pathetic. Words failed me when I tried to write about love. My thoughts seemed sentimental, silly, and superficial. When writing poetry in my girlhood, I had felt the same confidence I would come to see in my adult life only in male writers.

When I first began to write poetry in girlhood, I thought love was the only topic, the most important passion. Indeed, the first poem I published, at age twelve, was called "a look at love." Somewhere along the way, in that passage from girlhood to womanhood, I learned females really had nothing serious to teach the world about love.

Death became my chosen topic. No one around me, professors and students alike, doubted a woman's ability to be serious when it came to thinking and writing about death. All the poems in my first book were on the topic of death and dying. Even so, the poem that opened the book, "The woman's mourning song," was about the loss of a loved one and the refusal to let death destroy memory. Contemplating death has always been a subject that leads me back to love. Significantly, I began to think more about the meaning of love as I witnessed the deaths of many friends, comrades, and acquaintances, many of them dying young and unexpectedly. When I was approaching the age of forty and facing the type of cancer scares that have become so commonplace in women's lives they are practically routine, my first thought as I waited for test results was that I was not ready to die because I had not yet found the love my heart had been seeking.

Shortly after this crisis ended, I had a grave illness that was life threatening. Confronting the possibility of dying, I became obsessed with the meaning of love in my life and

in contemporary culture. My work as a cultural critic offered me a constant opportunity to pay close attention to everything the mass media, particularly movies and magazines, tell us about love. Mostly they tell us that everyone wants love but that we remain totally confused about the practice of love in everyday life. In popular culture love is always the stuff of fantasy. Maybe this is why men have done most of the theorizing about love. Fantasy has primarily been their domain, both in the sphere of cultural production and in everyday life. Male fantasy is seen as something that can create reality, whereas female fantasy is regarded as pure escape. Hence, the romance novel remains the only domain in which women speak of love with any degree of authority. However, when men appropriate the romance genre their work is far more rewarded than is the writing of women. A book like *The Bridges of Madison County* is the supreme example. Had a woman penned this sentimental, shallow story of love (which did, though, have its moments) it is unlikely it would ever have become such a major mainstream success, crossing all boundaries of genre.

Of course, consumers of books about love are primarily female. Yet male sexism alone does not explain the lack of more books by and about love written by women. Apparently, women are both willing and eager to hear what men have to say about love. Female sexist thinking may

lead a woman to feel she already knows what another woman will say. Such a reader may feel that she has more to gain by reading what men have to say.

Earlier in my life I read books about love and never thought about the gender of the writer. Eager to understand what we mean when we speak of love, I did not really consider the extent to which gender shaped a writer's perspective. It was only when I began to think seriously about the subject of love and to write about it that I pondered whether women do this differently from men.

Reviewing the literature on love I noticed how few writers, male or female, talk about the impact of patriarchy, the way in which male domination of women and children stands in the way of love. John Bradshaw's *Creating Love: The Next Great Stage of Growth* is one of my favorite books on the topic. He valiantly attempts to establish the link between male domination (the institutionalization of patriarchy) and the lack of love of families. Famous for work that calls attention to the "inner child," Bradshaw believes that ending patriarchy is one step in the direction of love. However, his work on love has never received ongoing attention and celebration. It did not get the notice given work by men who write about love while affirming sexist-defined gender roles.

Profound changes in the way we think and act must take place if we are to create a loving culture. Men writing

about love always testify that they have received love. They speak from this position; it gives what they say authority. Women, more often than not, speak from a position of lack, of not having received the love we long for.

A woman who talks of love is still suspect. Perhaps this is because all that enlightened woman may have to say about love will stand as a direct threat and challenge to the visions men have offered us. I enjoy what male writers have to say about love. I cherish my Rumi and my Rilke, male poets who stir hearts with their words. Men often write about love through fantasy, through what they imagine is possible rather than what they concretely know. We know now that Rilke did not write as he lived, that so many words of love offered us by great men fail us when we come face to face with reality. And even though John Gray's work troubles me and makes me mad, I confess to reading and rereading *Men Are from Mars, Women Are from Venus*. But, like many women and men, I want to know about the meaning of love beyond the realm of fantasy—beyond what we imagine can happen. I want to know love's truths as we live them.

Almost all the recent popular self-help writing by men on love, from works like *Men Are from Mars, Women Are from Venus* to John Welwood's *Love and Awakening*, make use of feminist perspectives on gender roles. Ultimately, though, the authors remain wedded to belief systems, which suggest that there are basic inherent dif-

ferences between women and men. In actuality, all the concrete proof indicates that while the perspectives of men and women often differ, these differences are learned characteristics, not innate, or "natural," traits. If the notion that men and women were absolute opposites inhabiting totally different emotional universes were true, men would never have become the supreme authorities on love. Given gender stereotypes that assign to women the role of feelings and being emotional and to men the role of reason and non-emotion, "real men" would shy away from any talk of love.

Though considered the established "authorities" on the subject, only a few men talk freely, telling the world what they think about love. In everyday life males and females alike are relatively silent about love. Our silence shields us from uncertainty. We want to know love. We are simply afraid the desire to know too much about love will lead us closer and closer to the abyss of lovelessness. While ours is a nation wherein the vast majority of citizens are followers of religious faiths that proclaim the transformative power of love, many people feel that they do not have a clue as to how to love. And practically everyone suffers a crisis of faith when it comes to realizing biblical theories about the art of loving in everyday life. It is far easier to talk about loss than it is to talk about love. It is easier to articulate the pain of love's absence than to describe its presence and meaning in our lives.

Taught to believe that the mind, not the heart, is the seat of learning, many of us believe that to speak of love with any emotional intensity means we will be perceived as weak and irrational. And it is especially hard to speak of love when what we have to say calls attention to the fact that lovelessness is more common than love, that many of us are not sure what we mean when we talk of love or how to express love.

Everyone wants to know more about love. We want to know what it means to love, what we can do in our everyday lives to love and be loved. We want to know how to seduce those among us who remain wedded to lovelessness and open the door to their hearts to let love enter. The strength of our desire does not change the power of our cultural uncertainty. Everywhere we learn that love is important, and yet we are bombarded by its failure. In the realm of the political, among the religious, in our families, and in our romantic lives, we see little indication that love informs decisions, strengthens our understanding of community, or keeps us together. This bleak picture in no way alters the nature of our longing. We still hope that love will prevail. We still believe in love's promise.

Just as the graffiti proclaimed, our hope lies in the reality that so many of us continue to believe in love's power. We believe it is important to know love. We believe it is important to search for love's truths. In an overwhelming number of private conversations and public

dialogues, I have given and heard testimony about the mounting lovelessness in our culture and the fear it strikes in everyone's heart. This despair about love is coupled with a callous cynicism that frowns upon any suggestion that love is as important as work, as crucial to our survival as a nation as the drive to succeed. Awesomely, our nation, like no other in the world, is a culture driven by the quest to love (it's the theme of our movies, music, literature) even as it offers so little opportunity for us to understand love's meaning or to know how to realize love in word and deed.

Our nation is equally driven by sexual obsession. There is no aspect of sexuality that is not studied, talked about, or demonstrated. How-to classes exist for every dimension of sexuality, even masturbation. Yet schools for love do not exist. Everyone assumes that we will know how to love instinctively. Despite overwhelming evidence to the contrary, we still accept that the family is the primary school for love. Those of us who do not learn how to love among family are expected to experience love in romantic relationships. However, this love often eludes us. And we spend a lifetime undoing the damage caused by cruelty, neglect, and all manner of lovelessness experienced in our families of origin and in relationships where we simply did not know what to do.

Only love can heal the wounds of the past. However, the intensity of our woundedness often leads to a closing

of the heart, making it impossible for us to give or receive the love that is given to us. To open our hearts more fully to love's power and grace we must dare to acknowledge how little we know of love in both theory and practice. We must face the confusion and disappointment that much of what we were taught about the nature of love makes no sense when applied to daily life. Contemplating the practice of love in everyday life, thinking about how we love and what is needed for ours to become a culture where love's sacred presence can be felt everywhere, I wrote this meditation.

As the title *All About Love: New Visions* indicates, we want to live in a culture where love can flourish. We yearn to end the lovelessness that is so pervasive in our society. This book tells us how to return to love. *All About Love: New Visions* provides radical new ways to think about the art of loving, offering a hopeful, joyous vision of love's transformative power. It lets us know what we must do to love again. Gathering love's wisdom, it lets us know what we must do to be touched by love's grace.

All About Love

One

CLARITY:

GIVE LOVE WORDS

As a society we are embarrassed by love. We treat it as if it were an obscenity. We reluctantly admit to it. Even saying the word makes us stumble and blush . . . Love is the most important thing in our lives, a passion for which we would fight or die, and yet we're reluctant to linger over its names. Without a supple vocabulary, we can't even talk or think about it directly.

— DIANE ACKERMAN

THE MEN IN my life have always been the folks who are wary of using the word "love" lightly. They are wary because they believe women make too much of love. And they know that what we think love means is not always what they believe it means. Our confusion about what we mean when we use the word "love" is the source of our difficulty in loving. If our society had a commonly held understanding of the meaning of love, the act of loving would not be so mystifying. Dictionary definitions of love tend to emphasize romantic love, defining love first and foremost as "profoundly tender, passionate affection for another person, especially when based on sexual attraction." Of course, other definitions let the reader know one may have such feelings within a context that is not sexual. However, deep affection does not really adequately describe love's meaning.

The vast majority of books on the subject of love work

hard to avoid giving clear definitions. In the introduction to Diane Ackerman's *A Natural History of Love,* she declares "Love is the great intangible." A few sentences down from this she suggests: "Everyone admits that love is wonderful and necessary, yet no one can agree on what it is." Coyly, she adds: "We use the word love in such a sloppy way that it can mean almost nothing or absolutely everything." No definition ever appears in her book that would help anyone trying to learn the art of loving. Yet she is not alone in writing of love in ways that cloud our understanding. When the very meaning of the word is cloaked in mystery, it should not come as a surprise that most people find it hard to define what they mean when they use the word "love."

Imagine how much easier it would be for us to learn how to love if we began with a shared definition. The word "love" is most often defined as a noun, yet all the more astute theorists of love acknowledge that we would all love better if we used it as a verb. I spent years searching for a meaningful definition of the word "love," and was deeply relieved when I found one in psychiatrist M. Scott Peck's classic self-help book *The Road Less Traveled*, first published in 1978. Echoing the work of Erich Fromm, he defines love as "the will to extend one's self for the purpose of nurturing one's own or another's spiritual growth." Explaining further, he continues: "Love is as love does. Love is an act of will—namely,

both an intention and an action. Will also implies choice. We do not have to love. We choose to love." Since the choice must be made to nurture growth, this definition counters the more widely accepted assumption that we love instinctually.

Everyone who has witnessed the growth process of a child from the moment of birth on sees clearly that before language is known, before the identity of caretakers is recognized, babies respond to affectionate care. Usually they respond with sounds or looks of pleasure. As they grow older they respond to affectionate care by giving affection, cooing at the sight of a welcomed caretaker. Affection is only one ingredient of love. To truly love we must learn to mix various ingredients—care, affection, recognition, respect, commitment, and trust, as well as honest and open communication. Learning faulty definitions of love when we are quite young makes it difficult to be loving as we grow older. We start out committed to the right path but go in the wrong direction. Most of us learn early on to think of love as a feeling. When we feel deeply drawn to someone, we cathect with them; that is, we invest feelings or emotion in them. That process of investment wherein a loved one becomes important to us is called "cathexis." In his book Peck rightly emphasizes that most of us "confuse cathecting with loving." We all know how often individuals feeling connected to someone through the process of cathecting insist that they love the other

person even if they are hurting or neglecting them. Since their feeling is that of cathexis, they insist that what they feel is love.

When we understand love as the will to nurture our own and another's spiritual growth, it becomes clear that we cannot claim to love if we are hurtful and abusive. Love and abuse cannot coexist. Abuse and neglect are, by definition, the opposites of nurturance and care. Often we hear of a man who beats his children and wife and then goes to the corner bar and passionately proclaims how much he loves them. If you talk to the wife on a good day, she may also insist he loves her, despite his violence. An overwhelming majority of us come from dysfunctional families in which we were taught we were not okay, where we were shamed, verbally and/or physically abused, and emotionally neglected even as were also taught to believe that we were loved. For most folks it is just too threatening to embrace a definition of love that would no longer enable us to see love as present in our families. Too many of us need to cling to a notion of love that either makes abuse acceptable or at least makes it seem that whatever happened was not that bad.

Raised in a family in which aggressive shaming and verbal humiliation coexisted with lots of affection and care, I had difficulty embracing the term "dysfunctional." Since I felt and still feel attached to my parents and siblings, proud of all the positive dimensions of our family life, I

did not want to describe us by using a term that implied our life together had been all negative or bad. I did not want my parents to think I was disparaging them; I was appreciative of all the good things that they had given in the family. With therapeutic help I was able to see the term "dysfunctional" as a useful description and not as an absolute negative judgment. My family of origin provided, throughout my childhood, a dysfunctional setting and it remains one. This does not mean that it is not also a setting in which affection, delight, and care are present.

On any day in my family of origin I might have been given caring attention wherein my being a smart girl was affirmed and encouraged. Then, hours later, I would be told that it was precisely because I thought I was so smart that I was likely to go crazy and be put in a mental institution where no one would visit me. Not surprisingly, this odd mixture of care and unkindness did not positively nurture the growth of my spirit. Applying Peck's definition of love to my childhood experience in my household of origin, I could not honestly describe it as loving.

Pressed in therapy to describe my household of origin in terms of whether it was loving or not, I painfully admitted that I did not feel loved in our household but that I did feel cared for. And outside my household of origin I felt genuinely loved by individual family members, like my grandfather. This experience of genuine love (a combination of care, commitment, trust, knowledge, respon-

sibility, and respect) nurtured my wounded spirit and enabled me to survive acts of lovelessness. I am grateful to have been raised in a family that was caring, and strongly believe that had my parents been loved well by *their* parents they would have given that love to their children. They gave what they had been given—care. Remember, care is a dimension of love, but simply giving care does not mean we are loving.

Like many adults who were verbally and/or physically abused as children, I spent a lot of my life trying to deny the bad things that had happened, trying to cling only to the memory of good and delicious moments in which I had known care. In my case, the more successful I became, the more I wanted to cease speaking the truth about my childhood. Often, critics of self-help literature and recovery programs like to make it seem that far too many of us are eager to embrace the belief that our families of origins were, are, or remain dysfunctional and lacking in love but I have found that, like myself, most people, whether raised in an excessively violent or abusive home or not, shy away from embracing any negative critique of our experiences. Usually, it requires some therapeutic intervention, whether through literature that teaches and enlightens us or therapy, before many of us can even begin to critically examine childhood experiences and acknowledge the ways in which they have had an impact on our adult behavior.

Most of us find it difficult to accept a definition of love

that says we are never loved in a context where there is abuse. Most psychologically and/or physically abused children have been taught by parenting adults that love can coexist with abuse. And in extreme cases that abuse is an expression of love. This faulty thinking often shapes our adult perceptions of love. So that just as we would cling to the notion that those who hurt us as children loved us, we try to rationalize being hurt by other adults by insisting that they love us. In my case, many of the negative shaming practices I was subjected to in childhood continued in my romantic adult relationships. Initially, I did not want to accept a definition of love that would also compel me to face the possibility that I had not known love in the relationships that were most primary to me. Years of therapy and critical reflection enabled me to accept that there is no stigma attached to acknowledging a lack of love in one's primary relationships. And if one's goal is self-recovery, to be well in one's soul, honestly and realistically confronting lovelessness is part of the healing process. A lack of sustained love does not mean the absence of care, affection, or pleasure. In fact, my long-term romantic relationships, like the bonds in my family, have been so full of care that it would be quite easy to overlook the ongoing emotional dysfunction.

In order to change the lovelessness in my primary relationships, I had to first learn anew the meaning of love and from there learn how to be loving. Embracing a definition

of love that was clear was the first step in the process. Like many who read *The Road Less Traveled* again and again, I am grateful to have been given a definition of love that helped me face the places in my life where love was lacking. I was in my mid-twenties when I first learned to understand love "as the will to extend one's self for the purpose of nurturing one's own or another's spiritual growth." It still took years for me to let go of learned patterns of behavior that negated my capacity to give and receive love. One pattern that made the practice of love especially difficult was my constantly choosing to be with men who were emotionally wounded, who were not that interested in being loving even though they desired to be loved.

I wanted to know love but I was afraid to surrender and trust another person. I was afraid to be intimate. By choosing men who were not interested in being loving, I was able to practice giving love, but always within an unfulfilling context. Naturally, my need to receive love was not met. I got what I was accustomed to getting—care and affection, usually mingled with a degree of unkindness, neglect, and, on some occasions, outright cruelty. At times I was unkind. It took me a long time to recognize that while I wanted to know love, I was afraid to be truly intimate. Many of us choose relationships of affection and care that will never become loving because they feel safer. The demands are not as intense as loving requires. The risk is not as great.

So many of us long for love but lack the courage to take risks. Even though we are obsessed with the idea of love, the truth is that most of us live relatively decent, somewhat satisfying lives even if we often feel that love is lacking. In these relationships we share genuine affection and/or care. For most of us, that feels like enough because it is usually a lot more than we received in our families of origin. Undoubtedly, many of us are more comfortable with the notion that love can mean anything to anybody precisely because when we define it with precision and clarity it brings us face to face with our lacks—with terrible alienation. The truth is, far too many people in our culture do not know what love is. And this not knowing feels like a terrible secret, a lack that we have to cover up.

Had I been given a clear definition of love earlier in my life it would not have taken me so long to become a more loving person. Had I shared with others a common understanding of what it means to love it would have been easier to create love. It is particularly distressing that so many recent books on love continue to insist that definitions of love are unnecessary and meaningless. Or worse, the authors suggest love should mean something different to men than it does to women—that the sexes should respect and adapt to our inability to communicate since we do not share the same language. This type of literature is popular because it does not demand a change in fixed ways of thinking about gender roles, culture, or love.

Rather than sharing strategies that would help us become more loving it actually encourages everyone to adapt to circumstances where love is lacking.

Women, more so than men, rush out to purchase this literature. We do so because collectively we are concerned about lovelessness. Since many women believe they will never know fulfilling love, they are willing to settle for strategies that help ease the pain and increase the peace, pleasure, and playfulness in existing relationships, particularly romantic ones. No vehicle in our culture exists for readers to talk back to the writers of this literature. And we do not really know if it has been truly useful, if it promotes constructive change. The fact that women, more than men, buy self-help books, using our consumer dollars to keep specific books on bestseller lists, is no indication that these books actually help us transform our lives. I have bought tons of self-help books. Only a very few have really made a difference in my life. This is true for many readers.

The lack of an ongoing public discussion and public policy about the practice of love in our culture and in our lives means that we still look to books as a primary source of guidance and direction. Large numbers of readers embrace Peck's definition of love and are applying it to their lives in ways that are helpful and transformative. We can spread the word by evoking this definition in day-to-day

conversations, not just when we talk to other adults but in our conversations with children and teenagers. When we intervene on mystifying assumptions that love cannot be defined by offering workable, useful definitions, we are already creating a context where love can begin to flourish.

Some folks have difficulty with Peck's definition of love because he uses the word "spiritual." He is referring to that dimension of our core reality where mind, body, and spirit are one. An individual does not need to be a believer in a religion to embrace the idea that there is an animating principle in the self—a life force (some of us call it soul) that when nurtured enhances our capacity to be more fully self-actualized and able to engage in communion with the world around us.

To begin by always thinking of love as an action rather than a feeling is one way in which anyone using the word in this manner automatically assumes accountability and responsibility. We are often taught we have no control over our "feelings." Yet most of us accept that we choose our actions, that intention and will inform what we do. We also accept that our actions have consequences. To think of actions shaping feelings is one way we rid ourselves of conventionally accepted assumptions such as that parents love their children, or that one simply "falls" in love without exercising will or choice, that there are such things as "crimes of passion," i.e., he killed her because

he loved her so much. If we were constantly remembering that love is as love does, we would not use the word in a manner that devalues and degrades its meaning. When we are loving we openly and honestly express care, affection, responsibility, respect, commitment, and trust.

Definitions are vital starting points for the imagination. What we cannot imagine cannot come into being. A good definition marks our starting point and lets us know where we want to end up. As we move toward our desired destination we chart the journey, creating a map. We need a map to guide us on our journey to love—starting with the place where we know what we mean when we speak of love.

Two

JUSTICE:
CHILDHOOD LOVE LESSONS

Severe separations in early life leave emotional scars on the brain because they assault the essential human connection: The [parent-child] bond which teaches us that we are lovable. The [parent-child] bond which teaches us how to love. We cannot be whole human beings—indeed, we may find it hard to be human—without the sustenance of this first attachment.

— JUDITH VIORST

WE LEARN ABOUT love in childhood. Whether our homes are happy or troubled, our families functional or dysfunctional, it's the original school of love. I cannot remember ever wanting to ask my parents to define love. To my child's mind love was the good feeling you got when family treated you like you mattered and you treated them like they mattered. Love was always and only about good feeling. In early adolescence when we were whipped and told that these punishments were "for our own good" or "I'm doing this because I love you," my siblings and I were confused. Why was harsh punishment a gesture of love? As children do, we pretended to accept this grown-up logic; but we knew in our hearts it was not right. We knew it was a lie. Just like the lie the grown-ups told when they explained after harsh punishment, "It hurts me more than it hurts you." There is nothing that creates more confusion about love in the minds and hearts of children than

unkind and/or cruel punishment meted out by the grown-ups they have been taught they should love and respect. Such children learn early on to question the meaning of love, to yearn for love even as they doubt it exists.

On the flip side there are masses of children who grow up confident love is a good feeling who are never punished, who are allowed to believe that love is only about getting your needs met, your desires satisfied. In their child's minds love is not about what they have to give, love is mostly something given to them. When children like these are overindulged either materially or by being allowed to act out, this is a form of neglect. These children, though not in any way abused or uncared for, are usually as unclear about love's meaning as their neglected and emotionally abandoned counterparts. Both groups have learned to think about love primarily in relation to good feelings, in the context of reward and punishment. From early childhood on, most of us remember being told we were loved when we did things pleasing to our parents. And we learned to give them affirmations of love when they pleased us. As children grow they associate love more with acts of attention, affection, and caring. They still see parents who attempt to satisfy their desires as giving love.

Children from all classes tell me that they love their parents and are loved by them, even those who are being hurt or abused. When asked to define love, small children pretty much agree that it's a good feeling, "like when you

have something to eat that you really like" especially if it's your f-a-v-o-r-i-t-e. They will say, "My mommy loves me 'cause she takes care of me and helps me do everything right." When asked how to love someone, they talk about giving hugs and kisses, being sweet and cuddly. The notion that love is about getting what one wants, whether it's a hug or a new sweater or a trip to Disneyland, is a way of thinking about love that makes it difficult for children to acquire a deeper emotional understanding.

We like to imagine that most children will be born into homes where they will be loved. But love will not be present if the grown-ups who parent do not how to love. Although lots of children are raised in homes where they are given some degree of care, love may not be sustained or even present. Adults across lines of class, race, and gender indict the family. Their testimony conveys worlds of childhood where love was lacking—where chaos, neglect, abuse, and coercion reigned supreme. In her recent book *Raised in Captivity: Why Does America Fail Its Children?,* Lucia Hodgson documents the reality of lovelessness in the lives of a huge majority of children in the United States. Every day thousands of children in our culture are verbally and physically abused, starved, tortured, and murdered. They are the true victims of intimate terrorism in that they have no collective voice and no rights. They remain the property of parenting adults to do with as they will.

There can be no love without justice. Until we live in a

culture that not only respects but also upholds basic civil rights for children, most children will not know love. In our culture the private family dwelling is the one institutionalized sphere of power that can easily be autocratic and fascistic. As absolute rulers, parents can usually decide without any intervention what is best for their children. If children's rights are taken away in any domestic household, they have no legal recourse. Unlike women who can organize to protest sexist domination, demanding both equal rights and justice, children can only rely on well-meaning adults to assist them if they are being exploited and oppressed in the home.

We all know that, irrespective of class or race, other adults rarely intervene to question or challenge what their peers are doing with "their" children.

At a fun party, mostly of educated, well-paid professionals, a multiracial, multigenerational evening, the subject of disciplining kids by hitting was raised. Almost all the guests over thirty spoke about the necessity of using physical punishment. Many of us in the room had been smacked, whipped, or beaten as children. Men spoke the loudest in defense of physical punishment. Women, mostly mothers, talked about hitting as a last resort, but one that they deployed when necessary.

As one man bragged about the aggressive beatings he had received from his mother, sharing that "they had been good for him," I interrupted and suggested that he might

not be the misogynist woman-hater he is today if he had not been brutally beaten by a woman as a child. Although it is too simplistic to assume that just because we are hit as kids we will grow up to be people who hit, I wanted the group to acknowledge that being physically hurt or abused by grown-ups when we are children has harmful consequences in our adult life.

A young professional, the mother of a small boy, bragged about the fact that she did not hit, that when her son misbehaved she clamped down on his flesh, pinching him until he got the message. But this, too, is a form of coercive abuse. The other guests supported this young mother and her husband in their methods. I was astounded. I was a lone voice speaking out for the rights of children.

Later, with other people, I suggested that had we all been listening to a man tell us that every time his wife or girlfriend does something he does not like he just clamps down on her flesh, pinching her as hard as he can, everyone would have been appalled. They would have seen the action as both coercive and abusive. Yet they could not acknowledge that it was wrong for an adult to hurt a child in this way. All the parents in that room claim that they are loving. All the people in that room were college educated. Most call themselves good liberals, supportive of civil rights and feminism. But when it came to the rights of children they had a different standard.

One of the most important social myths we must debunk if we are to become a more loving culture is the one that teaches parents that abuse and neglect can coexist with love. Abuse and neglect negate love. Care and affirmation, the opposite of abuse and humiliation, are the foundation of love. No one can rightfully claim to be loving when behaving abusively. Yet parents do this all the time in our culture. Children are told that they are loved even though they are being abused.

It is a testimony to the failure of loving practice that abuse is happening in the first place.

Many of the men who offer their personal testimony in *Boyhood, Growing Up Male* tell stories of random violent abuse by parents that inflicted trauma. In his essay "When My Father Hit Me," Bob Shelby describes the pain of repeated beatings by his dad, stating: "From these experiences with my father, I learned about the abuse of power. By physically hitting my mother and me, he effectively stopped us from reacting to his humiliation of us. We ceased to protest his violations of our boundaries and his ignoring our sense of being individuals with needs, demands and rights of our own." Throughout his essay Shelby expresses contradictory understandings about the meaning of love. On the one hand, he says: "I have no doubt that my father loved me, but his love became misdirected. He said he wanted to give me what he didn't have as a child." On the other hand, Shelby confesses:

"What he most showed me, however, was his difficulty in being loved. All his life he had struggled with feelings of being unloved." When Shelby describes his childhood it is clear that his dad had affection for him and also gave him care some of the time. However, his dad did not know how to give and receive love. The affection he gave was undermined by the abuse.

Writing from the space of adult recollection, Shelby talks about the impact of physical abuse on his boyhood psyche: "As the intensity of the pain of his hits increased, I felt the hurt in my heart. I realized what hurt me the most were my feelings of love for this man who was hitting me. I covered my love with a dark cloth of hate." A similar story is told by other men in autobiographical narrative—men of all classes and races. One of the myths about lovelessness is that it exists only among the poor and deprived. Yet lovelessness is not a function of poverty or material lack. In homes where material privileges abound, children suffer emotional neglect and abuse. In order to cope with the pain of wounds inflicted in childhood, most of the men in *Boyhood* sought some form of therapeutic care. To find their way back to love they had to heal.

Many men in our culture never recover from childhood unkindnesses. Studies show that males and females who are violently humiliated and abused repeatedly, with no caring intervention, are likely to be dysfunctional and will

be predisposed to abuse others violently. In Jarvis Jay Masters's book *Finding Freedom: Writings from Death Row,* a chapter called "Scars" recounts his recognition that a vast majority of the scars covering the bodies of fellow inmates (not all of whom were on death row) were not, as one might think, the result of violent adult inter-actions. These men were covered with scars from child-hood beatings inflicted by parenting adults. Yet, he reports, none of them saw themselves as the victims of abuse: "Throughout my many years of institutionaliza-tion, I, like so many of these men, unconsciously took refuge behind prison walls. Not until I read a series of books for adults who had been abused as children did I become committed to the process of examining my own childhood." Organizing the men for group discussion, Masters writes: "I spoke to them of the pain I had carried through more than a dozen institutions. And I explained how all these events ultimately trapped me in a pattern of lashing out against everything." Like many abused chil-dren, male and female, these men were beaten by mothers, fathers, and other parental caregivers."

When Masters's mother dies he feels grief that he can-not be with her. The other inmates do not understand this longing, since she neglected and abused him. He responds: "She had neglected me, but am I to neglect myself as well by denying that I wished I'd been with her when she died, that I still love her?" Even on death row, Masters's

heart remains open. And he can honestly confess to longing to give and receive love. Being hurt by parenting adults rarely alters a child's desire to love and be loved by them. Among grown-ups who were wounded in childhood, the desire to be loved by uncaring parents persists, even when there is a clear acceptance of the reality that this love will never be forthcoming.

Often, children will want to remain with parental caregivers who have hurt them because of their cathected feelings for those adults. They will cling to the misguided assumption that their parents love them even in the face of remembered abuse, usually by denying the abuse and focusing on random acts of care.

In the prologue to *Creating Love,* John Bradshaw calls this confusion about love "mystification." He shares: "I was brought up to believe that love is rooted in blood relationships. You naturally loved anyone in your family. Love was not a choice. The love I learned about was bound by duty and obligation. . . . My family taught me our culture's rules and beliefs about love . . . even with the best intentions our parents often confused love with what we would now call abuse." To demystify the meaning of love, the art and practice of loving, we need to use sound definitions of love when talking with children, and we also need to ensure that loving action is never tainted with abuse.

In a society like ours, where children are denied full civil

rights, it is absolutely crucial that parenting adults learn how to offer loving discipline. Setting boundaries and teaching children how to set boundaries for themselves prior to misbehavior is an essential part of loving parenting. When parents start out disciplining children by using punishment, this becomes the pattern children respond to. Loving parents work hard to discipline without punishment. This does not mean that they never punish, only that when they do punish, they choose punishments like time-outs or the taking away of privileges. They focus on teaching children how to be self-disciplining and how to take responsibility for their actions. Since the vast majority of us were raised in households where punishment was deemed the primary, if not the only, way to teach discipline, the fact that discipline can be taught without punishment surprises many people. One of the simplest ways children learn discipline is by learning how to be orderly in daily life, to clean up any messes they make. Just teaching a child to take responsibility for placing toys in the appropriate place after playtime is one way to teach responsibility and self-discipline. Learning to clean up the mess made during playtime helps a child learn to be responsible. And they can learn from this practical act how to cope with emotional mess.

WERE THERE CURRENT television shows that actually modeled loving parenting, parents could learn these skills.

Television shows oriented toward families often favorably represent children when they are overindulged, are disrespectful, or are acting out. Often they behave in a more adult manner than the parents. What we see on television today actually, at best, models for us inappropriate behavior, and in worst-case scenarios, unloving behaviors. A great example of this is a movie like *Home Alone,* which celebrates disobedience and violence. But television can portray caring, loving family interaction. There are whole generations of adults who talk nostalgically about how they wanted their families to be like the fictive portraits of family life portrayed on *Leave It to Beaver* or *My Three Sons.* We desired our families to be like those we saw on the screen because we were witnessing loving parenting, loving households. Expressing to parents our desire to have families like the ones we saw on the screen, we were often told that the families were not realistic. The reality was, however, that parents who come from unloving homes have never learned how to love and cannot create loving home environments or see them as realistic when watching them on television. The reality they are most familiar with and trust is the one they knew intimately.

There was nothing utopian about the way problems were resolved on these shows. Parent and child discussion, critical reflection, and finding a way to make amends was usually the process by which misbehavior was addressed. On both shows there was never just one parenting figure.

Even though the mother was absent on *My Three Sons,* the lovable Uncle Charlie was a second parent. In a loving household where there are several parental caregivers, when a child feels one parent is being unjust that child can appeal to another adult for mediation, understanding, or support. We live in a society where there are a growing number of single parents, female and male. But the individual parent can always choose a friend to be another parenting figure, however limited their interaction. This is why the categories of godmother and godfather are so crucial. When my best girlhood friend chose to have a child without a father in the household, I became the godmother, a second parenting figure.

My friend's daughter turns to me to intervene if there is a misunderstanding or miscommunication between her and her mom. Here's one small example. My adult friend had never received an allowance as a child and did not feel she had the available extra money to offer an allowance to her daughter. She also believed her daughter would use all the money to buy sweets. Telling me that her daughter was angry with her over this issue, she opened up the space for us to have a dialogue. I shared my belief that allowances are important ways to teach children discipline, boundaries, and working through desires versus needs. I knew enough about my friend's finances to challenge her insistence that she could not afford to pay a small allowance, while simultaneously encour-

aging her not to project the wrongs of her childhood onto the present. As to whether the daughter would buy candy, I suggested she give the allowance with a statement of hope that it would not be used for overindulgence and see what happened.

It all worked out just fine. Happy to have an allowance, the daughter chose to save her money to buy things she thought were really important. And candy was not on this list. Had there not been another adult parenting figure involved, it might have taken these two a longer time to resolve their conflict, and unnecessary estrangement and wounding might have occurred. Significantly, love and respectful interaction between two adults exemplified for the daughter (who was told about the discussion) ways of problem solving. By revealing her willingness to accept criticism and her capacity to reflect on her behavior and change, the mother modeled for her daughter, without losing dignity or authority, the recognition that parents are not always right.

Until we begin to see loving parenting in all walks of life in our culture, many people will continue to believe we can only teach discipline through punishment, and that harsh punishment is an acceptable way to relate to children. Because children can innately offer affection or respond to affectionate care by returning it, it is often assumed that they know how to love and therefore do not need to learn the art of loving. While the will to love is

present in very young children, they still need guidance in the ways of love. Grown-ups provide that guidance.

Love is as love does, and it is our responsibility to give children love. When we love children we acknowledge by our every action that they are not property, that they have rights—that we respect and uphold their rights.

Without justice there can be no love.

Three

HONESTY:
BE TRUE TO LOVE

When we reveal ourselves to our partner and find that this brings healing rather than harm, we make an important discovery—that intimate relationship can provide a sanctuary from the world of facades, a sacred space where we can be ourselves, as we are. . . . This kind of unmasking—speaking our truth, sharing our inner struggles, and revealing our raw edges—is sacred activity, which allows two souls to meet and touch more deeply.

—JOHN WELWOOD

I T I S N O accident that when we first learn about justice and fair play as children it is usually in a context where the issue is one of telling the truth. The heart of justice is truth telling, seeing ourselves and the world the way it is rather than the way we want it to be. In recent years sociologists and psychologists have documented the fact that we live in a nation where people are lying more and more each day. Philosopher Sissela Bok's book *Lying: Moral Choice in Public and Private Life* was among the first works to call attention to the grave extent to which lying has become accepted and commonplace in our daily interactions. M. Scott Peck's *The Road Less Traveled* includes an entire section on lying. In *The Dance of Deception,* Harriet Lerner, another widely read psychotherapist, calls attention to the way in which women are encouraged by sexist socialization to pretend and manipulate, to lie as a way to please. Lerner outlines the various ways in which

constant pretense and lying alienate women from their true feelings, how it leads to depression and loss of self-awareness.

Lies are told about the most insignificant aspects of daily life. When many of us are asked basic questions, like How are you today? a lie is substituted for the truth. Much of the lying people do in everyday life is done either to avoid conflict or to spare someone's feelings. Hence, if you are asked to come to dinner with someone whom you do not particularly like, you do not tell the truth or simply decline, you make up a story. You tell a lie. In such a situation it should be appropriate to simply decline if stating one's reasons for declining might unnecessarily hurt someone.

Lots of people learn how to lie in childhood. Usually they begin to lie to avoid punishment or to avoid disappointing or hurting an adult. How many of us can vividly recall childhood moments where we courageously practiced the honesty we had been taught to value by our parents, only to find that they did not really mean for us to tell the truth all the time. In far too many cases children are punished in circumstances where they respond with honesty to a question posed by an adult authority figure. It is impressed on their consciousness early on, then, that telling the truth will cause pain. And so they learn that lying is a way to avoid being hurt and hurting others.

Lots of children are confused by the insistence that they

simultaneously be honest and yet also learn how to practice convenient duplicity. As they mature they begin to see how often grown-ups lie. They begin to see that few people around them tell the truth. I was raised in a world where children were taught to tell the truth, but it did not take long for us to figure out that adults did not practice what they preached. Among my siblings, those who learned how to tell polite lies or say what grown-ups wanted to hear were always more popular and more rewarded than those of us who told the truth.

Among any group of kids it is never clear why some quickly learn the fine art of dissimulation (that is, taking on whatever appearance is needed to manipulate a situation) while others find it hard to mask true feeling. Since pretense is such an expected aspect of childhood play, it is a perfect context for mastering the art of dissimulation. Concealing the truth is often a fun part of childhood play, yet when it becomes a common practice it is a dangerous prelude to lying all the time.

Sometimes children are fascinated by lying because they see the power it gives them over adults. Imagine: A little girl goes to school and tells her teacher she is adopted, knowing all the while that this is not true. She revels in the attention received, both the sympathy and the understanding offered as well as the frustration and anger of her parents when the teacher calls to talk about this newly discovered information. A friend of mine who lies a lot

tells me she loves fooling people and making them act on knowledge that only she knows is untrue; she is ten years old.

When I was her age I was frightened by lies. They confused me and they created confusion. Other kids poked fun at me because I was not good at lying. In the one truly violent episode between my mother and father, he accused her of lying to him. Then there was the night an older sister lied and said she was baby-sitting when she was actually out on a date. As he hit her, our father kept yelling, "Don't you lie to me!" While the violence of his response created in us a terror of the consequences of lying, it did not alter the reality that we knew he did not always tell the truth. His favorite way of lying was withholding. His motto was "just remain silent" when asked questions, then you will not get "caught in a lie."

The men I have loved have always lied to avoid confrontation or take responsibility for inappropriate behavior. In Dorothy Dinnerstein's groundbreaking book *The Mermaid and the Minotaur: Sexual Arrangements and Human Malaise,* she shares the insight that when a little boy learns that his powerful mother, who controls his life, really has no power within a patriarchy, it confuses him and causes rage. Lying becomes one of the strategic ways he can "act out" and render his mother powerless. Lying enables him to manipulate the mother even as he exposes her lack of power. This makes him feel more powerful.

Males learn to lie as a way of obtaining power, and females not only do the same but they also lie to pretend powerlessness. In her work Harriet Lerner talks about the way in which patriarchy upholds deception, encouraging women to present a false self to men and vice versa. In Dory Hollander's *101 Lies Men Tell Women*, she confirms that while both women and men lie, her data and the findings of other researchers indicate that "men tend to lie more and with more devastating consequences." For many young males the earliest experience of power over others comes from the thrill of lying to more powerful adults and getting away with it. Lots of men shared with me that it was difficult for them to tell the truth if they saw that it would hurt a loved one. Significantly, the lying many boys learn to do to avoid hurting Mom or whomever becomes so habitual that it becomes hard for them to distinguish a lie from the truth. This behavior carries over into adulthood.

Often, men who would never think of lying in the workplace lie constantly in intimate relationships. This seems to be especially the case for heterosexual men who see women as gullible. Many men confess that they lie because they can get away with it; their lies are forgiven. To understand why male lying is more accepted in our lives we have to understand the way in which power and privilege are accorded men simply because they are males within a patriarchal culture. The very concept of "being a man"

and a "real man" has always implied that when necessary men can take action that breaks the rules, that is above the law. Patriarchy tells us daily through movies, television, and magazines that men of power can do whatever they want, that it's this freedom that makes them men. The message given males is that to be honest is to be "soft." The ability to be dishonest and indifferent to the consequences makes a male hard, separates the men from the boys.

John Stoltenberg's book *The End of Manhood: A Book for Men of Conscience* analyzes the extent to which the masculine identity offered men as the ideal in patriarchal culture is one that requires all males to invent and invest in a false self. From the moment little boys are taught they should not cry or express hurt, feelings of loneliness, or pain, that they must be tough, they are learning how to mask true feelings. In worst-case scenarios they are learning how to not feel anything ever. These lessons are usually taught to males by other males and sexist mothers. Even boys raised in the most progressive, loving households, where parents encourage them to express emotions, learn a different understanding about masculinity and feelings on the playground, in the classroom, playing sports, or watching television. They may end up choosing patriarchal masculinity to be accepted by other boys and affirmed by male authority figures.

In his important work *Rediscovering Masculinity,*

Victor Seidler stresses: "When we learn to use language as boys, we very quickly learn how to conceal ourselves through language. We learn to 'master' language so that we can control the world around us. . . . Even though we learn to blame others for our unhappiness and misery in relationships we also know at some unspoken level how our masculinity has been limited and injured as we touch the hurt and pain of realizing how little we seem to feel about anything. . . ." Estrangement from feelings makes it easier for men to lie because they are often in a trance state, utilizing survival strategies of asserting manhood that they learned as boys. This inability to connect with others carries with it an inability to assume responsibility for causing pain. This denial is most evident in cases where men seek to justify extreme violence toward those less powerful, usually women, by suggesting they are the ones who are really victimized by females.

Regardless of the intensity of the male masquerade, inwardly many men see themselves as the victims of lovelessness. Like everyone, they learned as children to believe that love would be present in their lives. Although so many boys are taught to behave as though love does not matter, in their hearts they yearn for it. That yearning does not go away simply because they become men. Lying, as one form of acting out, is a way they articulate ongoing rage at the failure of love's promise. To embrace patriarchy, they must actively surrender the longing to love.

Patriarchal masculinity requires of boys and men not only that they see themselves as more powerful and superior to women but that they do whatever it takes to maintain their controlling position. This is one of the reasons men, more so than women, use lying as a means of gaining power in relationships. A commonly accepted assumption in a patriarchal culture is that love can be present in a situation where one group or individual dominates another. Many people believe men can dominate women and children yet still be loving. Psychoanalyst Carl Jung insightfully emphasized the truism that "where the will to power is paramount love will be lacking." Talk to any group of women about their relationships with men, no matter their race or class, and you will hear stories about the will to power, about the way men use lying, and that includes withholding information, as a way to control and subordinate.

IT IS NO accident that greater cultural acceptance of lying in this society coincided with women gaining greater social equality. Early on in the feminist movement women insisted that men had the upper hand, because they usually controlled the finances. Now that women's earning power has greatly increased (though it is not on a par with men's), and women are more economically independent, men who want to maintain dominance must deploy subtler strategies to colonize and disempower them. Even the

wealthiest professional woman can be "brought down" by being in a relationship where she longs to be loved and is consistently lied to. To the degree that she trusts her male companion, lying and other forms of betrayal will most likely shatter her self-confidence and self-esteem.

Allegiance to male domination requires of men who embrace this thinking (and many, if not most, do) that they maintain dominance over women "by any means necessary." While much cultural attention is given to domestic violence and practically everyone agrees it is wrong for men to hit women as a way of subordinating us, most men use psychological terrorism as a way to subordinate women. This is a socially acceptable form of coercion. And lying is one of the most powerful weapons in this arsenal. When men lie to women, presenting a false self, the terrible price they pay to maintain "power over" us is the loss of their capacity to give and receive love. Trust is the foundation of intimacy. When lies erode trust, genuine connection cannot take place. While men who dominate others can and do experience ongoing care, they place a barrier between themselves and the experience of love.

All visionary male thinkers challenging male domination insist that men can return to love only by repudiating the will to dominate. In *The End of Manhood*, Stoltenberg continually emphasizes that men can honor their own selfhood only through loving justice. He asserts: "Justice between people is perhaps the most important connection

people can have." Loving justice for themselves and others enables men to break the chokehold of patriarchal masculinity. In the chapter titled "How We Can Have Better Relationships with the Women in Our Lives," Stoltenberg writes: "Loving justice between a man and a woman does not stand a chance when other men's manhood matters more. When a man has decided to love manhood more than justice, there are predictable consequences in all his relationships with women. . . . Learning to live as a man of conscience means deciding that your loyalty to the people whom you love is always more important than whatever lingering loyalty you may sometimes feel to other men's judgment on your manhood." When men and women are loyal to ourselves and others, when we love justice, we understand fully the myriad ways in which lying diminishes and erodes the possibility of meaningful, caring connection, that it stands in the way of love.

Since the values and behavior of men are usually the standards by which everyone in our culture determines what is acceptable, it is important to understand that condoning lying is an essential component of patriarchal thinking for everyone. Men are by no means the only group who use lies as a way of gaining power over others. Indeed, if patriarchal masculinity estranges men from their selfhood, it is equally true that women who embrace patriarchal femininity, the insistence that females should act as though they are weak, incapable of rational thought,

dumb, silly, are also socialized to wear a mask—to lie. This is one of the primary themes in Lerner's *The Dance of Deception*. With shrewd insight she calls women to account for our participation in structures of pretense and lies—particularly within family life. Women are often comfortable lying to men in order to manipulate them to give us things we feel we want or deserve. We may lie to bolster a male's self-esteem. These lies may take the form of pretending to feel emotions we do not feel to pretending levels of emotional vulnerability and neediness that are false.

Heterosexual women are often schooled by other women in the art of lying to men as a way to manipulate. Many examples of the support females receive for lying concern the desire to mate and bear children. When I longed to have a baby and my male partner at the time was not ready, I was stunned by the number of women who encouraged me to disregard his feelings, to go ahead without telling him. They felt it was fine to deny a child the right to be desired by both female and male biological parents. (No deception is involved when a woman has a child with a sperm donor, as in such a case there is no visible male parent to reject or punish an unwanted child.) It disturbed me that women I respected did not take the need for male parenting seriously or believe that it was as important for a man to want to parent as a woman. Whether we like it or not we still live in a world where children want to

know who their fathers are and, when they can, go in search of absent fathers. I could not imagine bringing a child into this world whose father might reject him or her because he did not desire a child in the first place.

Growing up in the fifties, in the days before adequate birth control, every female was acutely conscious of the way unwanted pregnancies could alter the course of a young woman's life. Still, it was clear then that there were girls who hoped for pregnancy to emotionally bind individual males to them forever. I thought those days were long gone. Yet even in this era of social equality between the sexes I hear stories of females choosing to get pregnant when a relationship is rocky as a way of forcing the male to remain in their life or in the hope of forcing marriage. More than we might think, some men feel extremely bound to a woman when she gives birth to a child they have fathered. The fact that men succumb to being lied to and manipulated when the issue is biological parenting does not make it right or just. Men who accept being lied to and manipulated are not only abdicating their power, they are setting up a situation where they can "blame" women or justify woman-hating.

This is another case where lying is used to gain power over someone, to hold them against their will. Harriet Lerner reminds readers that honesty is only one aspect of truth telling—that it is equated with "moral excellence:

an absence of deception or fraud." The mask of patriar-chal "femininity" often renders women's deceptions ac-ceptable. However, when women lie we lend credence to age-old sexist stereotypes that suggest women are inher-ently, by virtue of being female, less capable of truth tell-ing. The origins of this sexist stereotype extend back to ancient stories of Adam and Eve, of Eve's willingness to lie even to God.

Often, when information is withheld by women and men, protection of privacy is the justification. In our cul-ture privacy is often confused with secrecy. Open, honest, truth-telling individuals value privacy. We all need spaces where we can be alone with thoughts and feelings—where we can experience healthy psychological autonomy and can choose to share when we want to. Keeping secrets is usually about power, about hiding and concealing infor-mation. Hence, many recovery programs stress that "you are only as sick as your secrets." When a former boy-friend's sister shared with me a carefully guarded family secret regarding incest, which he did not know about, I responded by requesting that she tell him. If she didn't, I would. I felt that keeping this information a secret from him would violate the commitment we had made as a cou-ple to be open and honest with each other. By withholding this information from him, joining his mother and sisters, I would have been participating in family dysfunction.

Sharing with him affirmed my loyalty and respect for his capacity to cope with reality.

While privacy strengthens all our bonds, secrecy weakens and damages connection. Lerner points out that we do not usually "know the emotional costs of keeping a secret" until the truth is disclosed. Usually, secrecy involves lying. And lying is always the setting for potential betrayal and violation of trust.

Widespread cultural acceptance of lying is a primary reason many of us will never know love. It is impossible to nurture one's own or another's spiritual growth when the core of one's being and identity is shrouded in secrecy and lies. Trusting that another person always intends your good, having a core foundation of loving practice, cannot exist within a context of deception. It is this truism that makes all acts of judicious withholding major moral dilemmas. More than ever before we, as a society, need to renew a commitment to truth telling. Such a commitment is difficult when lying is deemed more acceptable than telling the truth. Lying has become so much the accepted norm that people lie even when it would be simpler to tell the truth.

Practically every mental health care practictioner, from the most erudite psychoanalysts to untrained self-help gurus, tell us that it is infinitely more fulfilling and we are all saner if we tell the truth, yet most of us are not rushing to stand up and be counted among the truth tellers. In-

deed, as someone committed to being honest in daily life I experience the constant drag of being seen as a "freak" for telling the truth, even when I speak truthfully about simple matters. If a friend gives me a gift and asks me to tell him or her whether or not I like it, I will respond honestly and judiciously; that is to say, I will speak the truth in a positive, caring manner. Yet even in this situation, the person who asks for honesty will often express annoyance when given a truthful response.

In today's world we are taught to fear the truth, to believe it always hurts. We are encouraged to see honest people as naive, as potential losers. Bombarded with cultural propaganda ready to instill in all of us the notion that lies are more important, that truth does not matter, we are all potential victims. Consumer culture in particular encourages lies. Advertising is one of the cultural mediums that has most sanctioned lying. Keeping people in a constant state of lack, in perpetual desire, strengthens the marketplace economy. Lovelessness is a boon to consumerism. And lies strengthen the world of predatory advertising. Our passive acceptance of lies in public life, particularly via the mass media, upholds and perpetuates lying in our private lives. In our public life there would be nothing for tabloid journalism to expose if we lived our lives out in the open, committed to truth telling. Commitment to knowing love can protect us by keeping us

wedded to a life of truth, willing to share ourselves openly and fully in both private and public life.

To know love we have to tell the truth to ourselves and to others. Creating a false self to mask fears and insecurities has become so common that many of us forget who we are and what we feel underneath the pretense. Breaking through this denial is always the first step in uncovering our longing to be honest and clear. Lies and secrets burden us and cause stress. When an individual has always lied, he has no awareness that truth telling can take away this heavy burden. To know this he must let the lies go.

When feminism first began, women talked openly about our desires to know men better, to love them for who they really are. We talked about our desires to be loved for who we really are (i.e., to be accepted in our physical and spiritual beings rather than feeling we had to make ourselves into a fantasy self to become the object of male desire). And we urged men to be true to themselves, to express themselves. Then when men began to share their thoughts and feelings, some women could not cope. They wanted the old lies and pretenses to be back in place. In the seventies, a popular Sylvia greeting card showed a woman seated in front of a fortune-teller gazing into a crystal ball. The caption on the front of the card read: "He never talks about his feelings." On the inside the response was: "Next year at 2:00 P.M. men will start talking about their feelings. And at 2:05 women all over America

will be sorry." When we hear another person's thoughts, beliefs, and feelings, it is more difficult to project on to them our perceptions of who they are. It is harder to be manipulative. At times women find it difficult to hear what many men have to say when what they tell us does not conform to our fantasies of who they are or who we want them to be.

The wounded child inside many males is a boy who, when he first spoke his truths, was silenced by paternal sadism, by a patriarchal world that did not want him to claim his true feelings. The wounded child inside many females is a girl who was taught from early childhood on that she must become something other than herself, deny her true feelings, in order to attract and please others. When men and women punish each other for truth telling we reinforce the notion that lies are better. To be loving we willingly hear each other's truth and, most important, we affirm the value of truth telling. Lies may make people feel better, but they do not help them to know love.

Four

COMMITMENT:
LET LOVE BE LOVE IN ME

Commitment is inherent in any genuinely loving relationship. Anyone who is truly concerned for the spiritual growth of another knows, consciously or instinctively, that he or she can significantly foster that growth only through a relationship of constancy.

— M. Scott Peck

COMMITMENT TO TRUTH telling lays the groundwork for the openness and honesty that is the heartbeat of love. When we can see ourselves as we truly are and accept ourselves, we build the necessary foundation for self-love. We have all heard the maxim "If you do not love yourself, you will be unable to love anyone else." It sounds good. Yet more often than not we feel some degree of confusion when we hear this statement. The confusion arises because most people who think they are not lovable have this perception because at some point in their lives they were socialized to see themselves as unlovable by forces outside their control. We are not born knowing how to love anyone, either ourselves or somebody else. However, we are born able to respond to care. As we grow we can give and receive attention, affection, and joy. Whether we learn how to love ourselves and others will depend on the presence of a loving environment.

Self-love cannot flourish in isolation. It is no easy task to be self-loving. Simple axioms that make self-love sound easy only make matters worse. It leaves many people wondering why, if it is so easy, they continue to be trapped by feelings of low self-esteem or self-hatred. Using a working definition of love that tells us it is the action we take on behalf of our own or another's spiritual growth provides us with a beginning blueprint for working on the issue of self-love. When we see love as a combination of trust, commitment, care, respect, knowledge, and responsibility, we can work on developing these qualities or, if they are already a part of who we are, we can learn to extend them to ourselves.

Many people find it helpful to critically examine the past, particularly childhood, to chart their internalization of messages that they were not worthy, not enough, that they were crazy, stupid, monstrous, and so on. Simply learning how we have acquired feelings of worthlessness rarely enables us to change things; it is usually only one stage in the process. I, like so many other people, have found it useful to examine negative thinking and behavioral patterns learned in childhood, particularly those shaping my sense of self and identity. However, this process alone did not ensure self-recovery. It was not enough. I share this because it is far too easy to stay stuck in simply describing, telling one's story over and over again, which

can be a way of holding on to grief about the past or holding on to a narrative that places blame on others.

While it is important for us to understand the origins of fragile self-esteem, it is also possible to bypass this stage (identifying when and where we received negative socialization) and still create a foundation for building self-love. Individuals who bypass this stage tend to move on to the next stage, which is actively introducing into our lives constructive life-affirming thought patterns and behavior. Whether a person remembers the details of being abused is not important. When the consequence of that abuse is a feeling of worthlessness, they can still engage in a process of self-recovery by finding ways to affirm self-worth.

The wounded heart learns self-love by first overcoming low self-esteem. Nathaniel Branden's lengthy work *Six Pillars of Self-Esteem* highlights important dimensions of self-esteem, "the practice of living consciously, self-acceptance, self-responsibility, self-assertiveness, living purposefully and the practice of personal integrity." Living consciously means we think critically about ourselves and the world we live in. We dare to ask ourselves the basic questions who, what, when, where, and why. Answering these questions usually provides us with a level of awareness that enlightens. Branden contends: "To live consciously means to seek to be aware of everything that bears on our actions, purposes, values, and goals—to the best

of our ability, whatever that ability may be—and to behave in accordance with that which we see and know." To live consciously we have to engage in critical reflection about the world we live in and know most intimately.

Usually it is through reflection that individuals who have not accepted themselves make the choice to stop listening to negative voices, within and outside the self, that constantly reject and devalue them. Affirmations work for anyone striving for self-acceptance. Although I had for years been interested in therapeutic modes of healing and self-help, affirmations always seemed to me a bit corny. My sister, who was then working as a therapist in the field of chemical dependency, encouraged me to give affirmations a try to see if I would experience any concrete changes in my outlook. I wrote affirmations relevant to my daily life and began to repeat them in the morning as part of my daily meditations. At the top of my list was the declaration: "I'm breaking with old patterns and moving forward with my life." I not only found them to be a tremendous energy boost—a way to kick off the day by my accentuating the positive—I also found it useful to repeat them during the day if I felt particularly stressed or was falling into the abyss of negative thinking. Affirmations helped restore my emotional equilibrium.

Self-acceptance is hard for many of us. There is a voice inside that is constantly judging, first ourselves and then others. That voice enjoys the indulgence of an endless nega-

tive critique. Because we have learned to believe negativity is more realistic, it appears more real than any positive voice. Once we begin to replace negative thinking with positive thinking, it becomes utterly clear that, far from being realistic, negative thinking is absolutely disenabling. When we are positive we not only accept and affirm ourselves, we are able to affirm and accept others.

The more we accept ourselves, the better prepared we are to take responsibility in all areas of our lives. Commenting on this third pillar of self-esteem, Branden defines self-responsibility as the willingness "to take responsibility for my actions and the attainment of my goals . . . for my life and well-being." Taking responsibility does not mean that we deny the reality of institutionalized injustice. For example, racism, sexism, and homophobia all create barriers and concrete incidents of discrimination. Simply taking responsibility does not mean that we can prevent discriminatory acts from happening. But we can choose how we respond to acts of injustice. Taking responsibility means that in the face of barriers we still have the capacity to invent our lives, to shape our destinies in ways that maximize our well-being. Every day we practice this shape shifting to cope with realities we cannot easily change.

Many women are married to men who were unsupportive when they decided to further their educations. Most of these women did not leave the men in their lives, they engaged in constructive strategies of resistance.

One woman I spoke with was inhibited because her husband worked in a plant and she felt uncomfortable having more education than he did. Yet she wanted to reenter the workforce and needed an advanced degree to do so. She made the choice to take responsibility for her needs and desires, believing it would also enhance the well-being of her family. Returning to work boosted her self-esteem and changed the passive-aggressive rage and depression that had developed as a consequence of her isolation and stagnation. Making this decision and finding ways to realize it was not an easy process, however. Her husband and children were often disgruntled when her independence forced them to accept more household responsibility. In the long run, everyone benefited. And it goes without saying that these changes boosted her self-esteem in ways that showed her how self-love made it possible to extend herself in a constructive way to others. She was happier and so were those around her.

In order to makes these changes she had to make use of another vital aspect of self-esteem, "self-assertiveness," defined by Branden as "the willingness to stand up for myself, to be who I am openly, to treat myself with respect in all human encounters." Since many of us were shamed in childhood either in our families of origin or in school settings, a learned pattern of going along with the program and not making a fuss is the course of action we most frequently choose as a way to avoid conflict. As chil-

dren, conflict was often the setting for put-downs and hu-miliation, the place where we were shamed. Our attempts at self-assertion failed as an adequate defense. Many of us learned that passivity lessened the possibility of attack.

Sexist socialization teaches females that self-assertiveness is a threat to femininity. Accepting this faulty logic lays the groundwork for low self-esteem. The fear of being self-assertive usually surfaces in women who have been trained to be good girls or dutiful daughters. In our childhood home my brother was never punished for talking back. Asserting his opinions was a positive sign of manhood. When my sisters and I voiced our opinions we were told by our parenting adults that this was negative and unde-sirable behavior. We were told, especially by our dad, that female self-assertion was not feminine. We did not listen to these warnings. Even though ours was a patriarchal household, the fact that females far outnumbered the two males, my dad and my brother, made it safe for us to speak our minds, to talk back. Luckily, by the time we were young adults the feminist movement had come along and validated that having a voice and being self-assertive was necessary for building self-esteem.

One reason women have traditionally gossiped more than men is because gossip has been a social interaction wherein women have felt comfortable stating what they really think and feel. Often, rather than asserting what they think at the appropriate moment, women say what

they think will please the listener. Later, they gossip, stating at that moment their true thoughts. This division between a false self invented to please others and a more authentic self need not exist when we cultivate positive self-esteem.

THE FEMINIST MOVEMENT really helped women understand the personal power that is gained through positive self-assertiveness. Gloria Steinem's best-seller *Revolution from Within* cautioned women about the danger of achieving success without doing the necessary groundwork for self-love and self-esteem. She found that achieving women who still suffered internalized self-hatred invariably acted out in ways that undermined their success. And if the self-hating successful person did not act out she may have lived a life of private desperation, unable to tell anyone success does not, in fact, reverse crippled self-esteem. To complicate matters, women may feel the need to pretend that they are self-loving, to assert confidence and power to the outside world, and as a consequence they feel psychologically conflicted and disengaged from their true being. Shamed by the feeling that they can never let anyone know who they really are, they may choose isolation and aloneness for fear of being unmasked.

This is true of men as well. When powerful men reach the height of personal achievement in their careers, they

often undermine all they have worked for by engaging in self-destructive behavior. Men who reside at the bottom of our nation's economic totem pole do this and so do men at the top. President Clinton engaged in deceitful behavior, betraying both his personal commitments to his family as well as his political commitment to be a paragon of American values to the people of this country. He did so when his popularity was at an all-time high. Having spent much of his life achieving against the odds, his actions expose a fundamental flaw in his self-esteem. Although he is a white male, Ivy League–educated and economically well off, privileged, with all the accompanying perks, his irresponsible actions were a way of unmasking, of showing to the world that he really was not the "good guy" he was pretending to be. He created the context for a public shaming that no doubt mirrors moments of childhood shaming when some authority figure in his life made him feel he was worthless and that he would never be worthy no matter what he did. Anyone who suffers from low self-esteem can learn by his example. If we succeed without confronting and changing shaky foundations of low self-esteem rooted in contempt and hatred, we will falter along the way.

IT IS NO accident that "living purposely" is the sixth element of self-esteem. According to Branden it entails

taking responsibility for consciously creating goals, identifying the actions necessary to achieve them, making sure our behavior is in alignment with our goals, and paying attention to the outcome of our actions so that we see whether they are leading us where we want to go. Most people are concerned about living purposefully when it comes to choosing the work we do. Unfortunately, many workers feel they have very little freedom of choice when it comes to work. Most people do not grow up learning that the work we choose to do will have a major impact on our capacity to be self-loving.

Work occupies much of our time. Doing work we hate assaults our self-esteem and self-confidence. Yet most workers cannot do the work they love. But we can all enhance our capacity to live purposely by learning how to experience satisfaction in whatever work we do. We find that satisfaction by giving any job total commitment. When I had a teaching job I hated (the kind of job where you long to be sick so you have an excuse for not going to work), the only way I could ease the severity of my pain was to give my absolute best. This strategy enabled me to live purposely. Doing a job well, even if we do not enjoy what we are doing, means that we leave it with a feeling of well-being, our self-esteem intact. That self-esteem aids us when we go in search of a job that can be more fulfilling.

Throughout my life I have endeavored to not only do work I enjoy but to work with individuals I respect, like,

or love. When I first declared my desire to work in a loving environment, friends acted as though I had truly lost my mind. To them, love and work did not go together. But I was convinced that I would work better in a work environment shaped by an ethic of love. Today, as the Buddhist concept of "right livelihood" is more widely understood, more people embrace the belief that work that enhances our spiritual well-being strengthens our capacity to love. And when we work with love we create a loving working environment. Whenever I enter an office, I can immediately sense by the overall atmosphere and mood whether the workers like what they do. Marsha Sinetar writes about this concept in her book *Do What You Love, the Money Will Follow* as a way to encourage readers to take the risk of choosing work they care about and therefore learning through experience the meaning of right livelihood.

While there are many meaningful insights in Sinetar's book, it is equally true that we can do what we love and money will not always follow. Although this is utterly disappointing, it can also offer us the experiential awareness that doing what you love may be more important than making money. Sometimes, as has been the case in my life, I have had to work at a job that is less than enjoyable in order to have the means to do the work I love. At one point in a very mixed job career I worked as a cook in a club. I hated the noise and the smoke. But working nights left me free to write in the day, to do the work I truly

wanted to do. Each experience enhanced the value of the other. My nighttime work helped me relish the quiet serenity of my day and enjoy the alone time so essential to writing.

Whenever possible, it is best to seek work we love and to avoid work we hate. But sometimes we learn what we need to avoid by doing it. Individuals who are able to be economically self-sufficient doing what they love are blessed. Their experience serves as a beacon to all of us, showing us the ways right livelihood can strengthen self-love, ensuring peace and contentment in the lives we lead beyond work.

Often, workers believe that if their home life is good, it does not matter if they feel dehumanized and exploited on the job. Many jobs undermine self-love because they require that workers constantly prove their worth. Individuals who are dissatisfied and miserable on the job bring this negative energy home. Clearly, much of the violence in domestic life, both physical and verbal abuse, is linked to job misery. We can encourage friends and loved ones to move toward greater self-love by supporting them in any effort to leave work that assaults their well-being.

Folks who are out of the paid workforce, women and men who do unpaid work in the home, as well as all other happily unemployed people, are often doing what they want to do. While they are not rewarded by an income, their day-to-day life often provides more satisfaction than it would if they worked at a high-paying job in a stressful

and dehumanizing environment. Satisfied homemakers, both women and the rare men who have chosen to stay home, have a lot to teach us all about the joy that comes from self-determination. They are their own bosses, setting the terms of their labor and the measure of their reward. More than any of us, they have the freedom to develop right livelihood.

Most of us did not learn when we were young that our capacity to be self-loving would be shaped by the work we do and whether that work enhances our well-being. No wonder then that we have become a nation where so many workers feel bad. Jobs depress the spirit. Rather than enhancing self-esteem, work is perceived as a drag, a negative necessity. Bringing love into the work environment can create the necessary transformation that can make any job we do, no matter how menial, a place where workers can express the best of themselves. When we work with love we renew the spirit; that renewal is an act of self-love, it nurtures our growth. It's not what you do but how you do it.

In *The Knitting Sutra,* Susan Lydon describes the labor of knitting as a freely chosen craft that enhances her awareness of the value of right livelihood, sharing: "What I found in this tiny domestic world of knitting is endless; it runs broader and deeper than anyone might imagine. It is infinite and seemingly inexhaustible in its capacity to inspire, excite, and provoke creative insight." Lydon sees

the world that we have traditionally thought of as "woman's work" as a place to discover godliness through the act of creating domestic bliss. A blissful household is one where love can flourish.

Creating domestic bliss is especially useful for individuals living alone who are just learning to be self-loving. When we intentionally strive to make our homes places where we are ready to give and receive love, every object we place there enhances our well-being. I create themes for my different homes. My flat in the city has the theme "love's meeting place." As a small-town person moving to a big city I found that I needed my environment to truly feel like a sanctuary. Since my one-bedroom flat is so much smaller than the places I had been accustomed to living in, I decided to take only objects I truly loved—the things I felt I could not do without. It is amazing how much stuff you can just let go of. My country place has a desert theme. I call it *"soledad hermosa,"* beautiful solitude. I go there to be quiet and still and to experience the divine, to be renewed.

OF ALL THE chapters for this book, this one was the most difficult to write. When I talked with friends and acquaintances about self-love I was surprised to see how many of us feel troubled by the notion, as though the very idea implies too much narcissism or selfishness. We all need

to rid ourselves of misguided notions about self-love. We need to stop fearfully equating it with self-centeredness and selfishness.

Self-love is the foundation of our loving practice. Without it our other efforts to love fail. Giving ourselves love we provide our inner being with the opportunity to have the unconditional love we may have always longed to receive from someone else. Whenever we interact with others, the love we give and receive is always necessarily conditional. Although it is not impossible, it is very difficult and rare for us to be able to extend unconditional love to others, largely because we cannot exercise control over the behavior of someone else and we cannot predict or utterly control our responses to their actions. We can, however, exercise control over our own actions. We can give ourselves the unconditional love that is the grounding for sustained acceptance and affirmation. When we give this precious gift to ourselves, we are able to reach out to others from a place of fulfillment and not from a place of lack.

One of the best guides to how to be self-loving is to give ourselves the love we are often dreaming about receiving from others. There was a time when I felt lousy about my over-forty body, saw myself as too fat, too this, or too that. Yet I fantasized about finding a lover who would give me the gift of being loved as I am. It is silly, isn't it, that I would dream of someone else offering to me the

acceptance and affirmation I was withholding from my-self. This was a moment when the maxim "You can never love anybody if you are unable to love yourself" made clear sense. And I add, "Do not expect to receive the love from someone else you do not give yourself."

In an ideal world we would all learn in childhood to love ourselves. We would grow, being secure in our worth and value, spreading love wherever we went, letting our light shine. If we did not learn self-love in our youth, there is still hope. The light of love is always in us, no matter how cold the flame. It is always present, waiting for the spark to ignite, waiting for the heart to awaken and call us back to the first memory of being the life force inside a dark place waiting to be born—waiting to see the light.

Five

SPIRITUALITY:
DIVINE LOVE

As a woman and a lover, however, I am moved by the sight of my Beloved. Where He is, I want to be. What He suffers, I want to share. Who He is, I want to be: crucified for love.

—SAINT TERESA OF AVILA

LIVING LIFE IN touch with divine spirit lets us see the light of love in all living beings. That light is a resurrecting life force. A culture that is dead to love can only be resurrected by spiritual awakening. On the surface it appears that our nation has gone so far down the road of secular individualism, worshiping the twin gods of money and power, that there seems to be no place for spiritual life. Yet an overwhelming majority of Americans who express faith in Christianity, Judaism, Islam, Buddhism, or other religious traditions clearly believe that spiritual life is important. The crisis of American life does not seem to be generated by a lack of interest in spirituality. However, this interest is constantly co-opted by the powerful forces of materialism and hedonistic consumerism.

In the conclusion to his insightful work *The Art of Loving*, written in the mid-fifties but still relevant to today's

world, psychoanalyst Erich Fromm courageously calls attention to the reality that "the principle underlying capitalistic society and the principle of love are incompatible." He contends: "Our society is run by a managerial bureaucracy, by professional politicians; people are motivated by mass suggestion, their aim is producing more and consuming more, as purposes in themselves." The cultural emphasis on endless consumption deflects attention from spiritual hunger. We are endlessly bombarded by messages telling us that our every need can be satisfied by material increase. Artist Barbara Kruger created a work proclaiming "I shop therefore I am" to show the way consumerism has taken over mass consciousness, making people think they are what they possess. While the zeal to possess intensifies, so does the sense of spiritual emptiness. Because we are spiritually empty we try to fill up on consumerism. We may not have enough love but we can always shop.

Our national spiritual hunger springs from a keen awareness of the emotional lack in our lives. It is a response to lovelessness. Going to church or temple has not satisfied this hunger, surfacing from deep within our souls. Organized religion has failed to satisfy spiritual hunger because it has accommodated secular demands, interpreting spiritual life in ways that uphold the values of a production-centered commodity culture. This is as true of the traditional Christian church as it is of New Age spirituality. It is no accident that so many famous New Age

spiritual teachers link their teachings to a metaphysics of daily life that extolls the virtues of wealth, privilege, and power. For example, consider New Age logic, which suggests that the poor have chosen to be poor, have chosen their suffering. Such thinking removes from all of us who are privileged the burden of accountability. Rather than calling us to embrace love and greater community, it actually requires an investment in the logic of alienation and estrangement.

The basic interdependency of life is ignored so that separateness and individual gain can be deified. Religious fundamentalism is often represented as authentic spiritual practice and given a level of mass media exposure that countercultural religious thought and practice never receive. Usually, fundamentalists, be they Christian, Muslim, or any faith, shape and interpret religious thought to make it conform to and legitimize a conservative status quo. Fundamentalist thinkers use religion to justify supporting imperialism, militarism, sexism, racism, homophobia. They deny the unifying message of love that is at the heart of every major religious tradition.

No wonder then that so many people who claim to believe in religious teachings do not allow their habits of being to reflect these beliefs. For example, the Christian church remains one of the most racially segregated institutions in our society. In Martin Luther King, Jr.'s letter to American Christians, in which he assumes the persona

of the biblical apostle Paul, he admonishes believers for supporting segregation: "Americans, I must urge you to be rid of every aspect of segregation. Segregation is a blatant denial of the unity which we have in Christ. It substitutes an 'I-it' relationship for the 'I-thou' relationship, and relegates persons to the status of things. It scars the soul and degrades the personality. . . . It destroys community and makes brotherhood impossible." This is only one example of the way in which organized religious worship corrupts and violates religious principles about how we should live in the world and how we should act toward one another. Imagine how different our lives would be if all the individuals who claim to be Christians, or who claim to be religious, were setting an example for everyone by being loving.

Blatant misuses of spirituality and religious faith could lead us to despair about spiritual life if we were not simultaneously witnessing a genuine concern for spiritual awakening expressed counterculturally. Whether it is the American Buddhists working in solidarity to free Tibet or the many Christian-based organizations that provide support in the way of food and shelter for the needy globally, these embodiments of loving practice renew our hope and restore the soul. All around the world liberation theology offers the exploited and oppressed a vision of spiritual freedom that is linked to struggles to end domination.

A little more than ten years after Fromm first published

The Art of Loving, Martin Luther King, Jr.'s collection of sermons *Strength to Love* was published. The major focus of these talks was the celebration of love as a spiritual force that unites and binds all life. Like Fromm's earlier work, these essays championed spiritual life, critiquing capitalism, materialism, and the violence used to enforce exploitation and dehumanization. In a 1967 lecture opposing war King declared: "When I speak of love I am not speaking of some sentimental and weak response. I am speaking of that force which all of the great religions have seen as the supreme unifying principle of life. Love is somehow the key that unlocks the door which leads to ultimate reality. This Hindu-Moslem-Christian-Jewish-Buddhist belief about ultimate reality is beautifully summed up in the first epistle of Saint John: 'Let us love one another, for love is God and everyone that loveth is born of God and knoweth God.' " Throughout his life King was a prophet of love. In the late seventies, when it was no longer cool to talk about spirituality, I found myself turning again and again to his work and to the work of Thomas Merton. As religious seekers and thinkers, both men focused attention on the practice of love as a means of spiritual fulfillment.

Extolling the transformative power of love in his essay "Love and Need," Merton writes: "Love is, in fact an intensification of life, a completeness, a fullness, a wholeness of life. . . . Life curves upward to a peak of intensity,

a high point of value and meaning, at which all its latent creative possibility go into action and the person transcends himself or herself in encounter, response, and communion with another. It is for this that we came into the world—this communion and self-transcendence. We do not become fully human until we give ourselves to each other in love." The teachings about love offered by Fromm, King, and Merton differ from much of today's writing. There is always an emphasis in their work on love as an active force that should lead us into greater communion with the world. In their work, loving practice is not aimed at simply giving an individual greater life satisfaction; it is extolled as the primary way we end domination and oppression. This important politicization of love is often absent from today's writing.

Much as I enjoy popular New Age commentary on love, I am often struck by the dangerous narcissism fostered by spiritual rhetoric that pays so much attention to individual self-improvement and so little to the practice of love within the context of community. Packaged as a commodity, spirituality becomes no different from an exercise program. While it may leave the consumer feeling better about his or her life, its power to enhance our communion with ourselves and others in a sustained way is inhibited. Commenting on the value of an engaged life in *The Active Life: Wisdom for Work, Creativity, and Caring,* Parker Palmer writes: "To be fully alive is to act. . . . I understand

action to be any way that we can co-create reality with other beings and the Spirit. . . . Action, like a sacrament, is the visible form of an invisible spirit, an outward manifestation of an inward power. But as we act, we not only express what is in us and help give shape to the world; we also receive what is outside us, and reshape out inner selves." A commitment to a spiritual life requires us to do more than read a good book or go on a restful retreat. It requires conscious practice, a willingness to unite the way we think with the way we act.

Spiritual life is first and foremost about commitment to a way of thinking and behaving that honors principles of inter-being and interconnectedness. When I speak of the spiritual, I refer to the recognition within everyone that there is a place of mystery in our lives where forces that are beyond human desire or will alter circumstances and/or guide and direct us. I call these forces "divine spirit." When we choose to lead a spirit-filled life, we recognize and celebrate the presence of transcendent spirits. Some people call this presence soul, God, the Beloved, higher consciousness, or higher power. Still others say that this force is what it is because it cannot be named. To them it is simply the spirit moving in us and through us.

A commitment to spiritual life necessarily means we embrace the eternal principle that love is all, everything, our true destiny. Despite overwhelming pressure to conform to the culture of lovelessness, we still seek to know love.

That seeking is itself a manifestation of divine spirit. Life-threatening nihilism abounds in contemporary culture, crossing the boundaries of race, class, gender, and nationality. At some point it affects all our lives. Everyone I know is at times brought low by feelings of depression and despair about the state of the world. Whether it is the ongoing worldwide presence of violence expressed by the persistence of man-made war, hunger and starvation, the day-to-day reality of violence, the presence of life-threatening diseases that cause the unexpected deaths of friends, comrades, and loved ones, there is much that brings everyone to the brink of despair. Knowing love or the hope of knowing love is the anchor that keeps us from falling into that sea of despair. In *A Path with Heart,* Jack Kornfield shares: "The longing for love and the movement of love is underneath all of our activities."

Spirituality and spiritual life give us the strength to love. It is rare for individuals to choose a life in the spirit, one that honors the sacred dimensions of everyday life when they have had no contact with traditional religious thought or practice. Spiritual teachers are important guides who provide a catalyst for our spiritual awakening. Another source of spiritual growth is communion and fellowship with like-minded souls. Spiritual seekers let their light shine so that others may see not only to give service by example but also to constantly remind themselves that spirituality is most gloriously embodied in our actions—

our habits of being. Insightfully Jack Kornfield explains: "All other spiritual teachings are in vain if we cannot love. Even the most exalted states and the most exceptional spiritual accomplishments are unimportant if we cannot be happy in the most basic and ordinary ways, if, with our hearts, we cannot touch one another and the life we have been given. What matters is how we live."

For many of us, church was the place where we first heard a counternarrative of love, one that differed from the confused messages about love learned in dysfunctional families. The mystical dimensions of Christian faith (the belief that we are all one, that love is all) presented to me as a child in the church were the space of redemption. At church I learned not only to understand that God is love, I learned also that children were special in the heart and mind of divine spirit. Dreaming of becoming a writer, valuing the life of the mind above all things, it was especially awesome to learn by heart passages from First Corinthians, "the love chapter." From childhood on I have often reflected on the passage that proclaims: "If I speak with the tongues of men and of angels, but have not love, I am a noisy gong or a clanging cymbal. And if I have prophetic powers, and understand all mysteries and all knowledge, and if I have all faith so as to remove mountains, but have not love, I am nothing. If I give away all I have, and if I deliver my body to be burned, but have not love, I gain nothing." Throughout my graduate school

years, as I worked hard to finish my doctorate, striving to maintain a commitment to spiritual life in a world that did not value the spiritual, I returned to these lessons about the primacy of love. The wisdom they convey kept me from hardening my heart. Remaining open to love was crucial to my academic survival. When the environment you live in and know most intimately does not place value on loving, a spiritual life provides a place of solace and renewal.

Significantly, the gaining of knowledge about spirituality is not the same as a commitment to a spiritual life. Jack Kornfield testifies: "In undertaking a spiritual life, what matters is simple: We must make certain our path is connected with our heart. In beginning a genuine spiritual journey, we have to stay much closer to home, to focus directly on what is right here in front of us, to make sure that our path is connected with our deepest love." When we begin to experience the sacred in our everyday lives we bring to mundane tasks a quality of concentration and engagement that lifts the spirit. We recognize divine spirit everywhere. This is especially true when we face difficulties. So many people turn to spiritual thinking only when they experience difficulties, hoping that the sorrow or pain will just miraculously disappear. Usually, they find that the place of suffering—the place where we are broken in spirit, when accepted and embraced, is also a place of peace and possibility. Our sufferings do not magically end;

instead we are able to wisely alchemically recycle them. They become the abundant waste that we use to make new growth possible. That is why biblical scripture admonishes us to "count it all joy—when we meet various trials." Learning to embrace our suffering is one of the gifts offered by spiritual life and practice.

Spiritual practice does not need to be connected to organized religion in order to be meaningful. Some individuals find their sacred connection to life communing with the natural world and engaging in practices that honor life-sustaining ecosystems. We can mediate, pray, go to temple, church, mosque, or create a quiet sanctuary where we live to commune with holy spirits. To some folks, daily service to others is affirmative spiritual practice, one that expresses their love for others. When we make a commitment to staying in touch with divine forces that inform our inner and outer world, we are choosing to lead a life in the spirit.

I study spiritual teachings as a guide for reflection and action. Countercultural spiritual awakening is visible in books and magazines and in small circles where individuals come to celebrate and commune with the divine. Fellowship with other seekers after truth offers essential inspiration. Since the earliest roots of my spiritual practice were in the Christian tradition, I still find the traditional church to be a place for worship and fellowship, and I also participate in a Buddhist practice. I meditate and pray.

Everyone has to choose the spiritual practice that best enhances their life. This is why progressive seekers after truth urge us all to be tolerant—to remember that though our paths are many, we are made one community in love.

The spiritual awakening that is slowly taking place counterculturally will become more of a daily norm as we all willingly break mainstream cultural taboos that silence or erase our passion for spiritual practice. For a long time many of my friends and work peers had no idea I was devoted to a spiritual practice. Among progressive thinkers and scholars it was much more hip, cool, and acceptable to express atheistic sentiments than to declare passionate devotion to divine spirit. I also did not want folks to think that if I talked about my spiritual beliefs I was trying to convert them, to impose those beliefs on them in any way.

I began to speak more openly about the place of spirituality in my life when witnessing the despair of my students, their sense of hopelessness, their fears that life is without meaning, their profound loneliness and lovelessness. When young, bright, beautiful students would come to my office and confess their despondency, I felt it was irresponsible to just listen and commiserate with their woes without daring to share how I had confronted similar issues in my life. Often they would urge me to tell them how I sustained my joy in living. To tell the truth, I had

to be willing to talk openly about spiritual life. And I had to find a way to talk about my choices that did not imply that they would be the correct or right choices for someone else.

My belief that God is love—that love is everything, our true destiny—sustains me. I affirm these beliefs through daily meditation and prayer, through contemplation and service, through worship and loving kindness. In the introduction to *Lovingkindness,* Sharon Salzberg teaches that the Buddha described spiritual practice as "the liberation of the heart which is love." She urges us to remember that spiritual practice helps us overcome the feeling of isolation, which "uncovers the radiant, joyful heart within each of us and manifests this radiance to the world." Everyone needs to be in touch with the needs of their spirit. This connectedness calls us to spiritual awakening—to love. In the biblical book of John, a passage reminds us that "anyone who does not know love is still in death."

All awakening to love is spiritual awakening.

Six

VALUES:

LIVING BY A LOVE ETHIC

We must live for the day, and work for the day, when human society realigns itself with the radical love of God. In a truly democratic paradigm, there is no love of power for power's sake.

— MARIANNE WILLIAMSON

AWAKENING TO LOVE can happen only as we let go of our obsession with power and domination. Culturally, all spheres of American life—politics, religion, the workplace, domestic households, intimate relations—should and could have as their foundation a love ethic. The underlying values of a culture and its ethics shape and inform the way we speak and act. A love ethic presupposes that everyone has the right to be free, to live fully and well. To bring a love ethic to every dimension of our lives, our society would need to embrace change. At the end of *The Art of Loving*, Erich Fromm affirms that "important and radical changes are necessary, if love is to become a social and not a highly individualistic, marginal phenomenon." Individuals who choose to love can and do alter our lives in ways that honor the primacy of a love ethic. We do this by choosing to work with individuals we admire and respect; by committing to give our all to rela-

tionships; by embracing a global vision wherein we see our lives and our fate as intimately connected to those of everyone else on the planet.

Commitment to a love ethic transforms our lives by offering us a different set of values to live by. In large and small ways, we make choices based on a belief that honesty, openness, and personal integrity need to be expressed in public and private decisions. I chose to move to a small city so I could live in the same area as family even though it was not as culturally desirable as the place I left. Friends of mine live at home with aging parents, caring for them even though they have enough money to go elsewhere. Living by a love ethic we learn to value loyalty and a commitment to sustained bonds over material advancement. While careers and making money remain important agendas, they never take precedence over valuing and nurturing human life and well-being.

I know no one who has embraced a love ethic whose life has not become joyous and more fulfilling. The widespread assumption that ethical behavior takes the fun out of life is false. In actuality, living ethically ensures that relationships in our lives, including encounters with strangers, nurture our spiritual growth. Behaving unethically, with no thought to the consequences of our actions, is a bit like eating tons of junk food. While it may taste good, in the end the body is never really adequately nourished and remains in a constant state of lack and longing.

Our souls feel this lack when we act unethically, behaving in ways that diminish our spirits and dehumanize others.

TESTIMONY IN NEW AGE writing affirms the way in which embracing a love ethic transforms life for the good. Yet a lot of this information only reaches those of us who have class privilege. And often, individuals whose lives are rich in spiritual and material well-being, who have diverse friends from all walks of life who nurture their personal integrity, tell the rest of the world these things are impossible to come by. I am talking here about the many prophets of doom who tell us that racism will never end, sexism is here to stay, the rich will never share their resources. We would all be surprised if we could enter their lives for a day. Much of what they are telling us cannot be had, they have. But in keeping with a capitalist-based notion of well-being, they really believe there is not enough to go around, that the good life can be had only by a few.

Talking to a university audience recently I expressed my faith in the power of white people to speak out against racism, challenging and changing prejudice—emphatically stating that I definitely believe we can all change our minds and our actions. I stressed that this faith was not rooted in a utopian longing but, rather, that I believed this because of our nation's history of the many individuals who have offered their lives in the service of justice and freedom. When challenged by folks who claimed that

these individuals were exceptions, I agreed. But I then talked about the necessity of changing our thinking so that we see ourselves as being like the one who does change rather than among the among who refuse to change. What made these individuals exceptional was not that they were any smarter or kinder than their neighbors but that they were willing to live the truth of their values.

Here is another example. If you go door to door in our nation and talk to citizens about domestic violence, almost everyone will insist that they do not support male violence against women, that they believe it to be morally and ethically wrong. However, if you then explain that we can only end male violence against women by challenging patriarchy, and that means no longer accepting the notion that men should have more rights and privileges than women because of biological difference or that men should have the power to rule over women, that is when the agreement stops. There is a gap between the values they claim to hold and their willingness to do the work of connecting thought and action, theory and practice to realize these values and thus create a more just society.

Sadly, many of our nation's citizens are proud to live in one of the most democratic countries in the world even as they are afraid to stand up for individuals who live under repressive and fascist governments. They are afraid to act on what they believe because it would mean challenging the conservative status quo. Refusal to stand up

for what you believe in weakens individual morality and ethics as well as those of the culture. No wonder then that we are a nation of people, the majority of whom, across race, class, and gender, claim to be religious, claim to believe in the divine power of love, and yet collectively remain unable to embrace a love ethic and allow it to guide behavior, especially if doing so would mean supporting radical change.

Fear of radical changes leads many citizens of our nation to betray their minds and hearts. Yet we are all subjected to radical changes every day. We face them by moving through fear. These changes are usually imposed by the status quo. For example, revolutionary new technologies have led us all to accept computers. Our willingness to embrace this "unknown" shows that we are all capable of confronting fears of radical change, that we can cope. Obviously, it is not in the interest of the conservative status quo to encourage us to confront our collective fear of love. An overall cultural embrace of a love ethic would mean that we would all oppose much of the public policy conservatives condone and support.

Society's collective fear of love must be faced if we are to lay claim to a love ethic that can inspire us and give us the courage to make necessary changes. Writing about the changes that must be made, Fromm explains: "Society must be organized in such a way that man's social, loving nature is not separated from his social existence, but be-

comes one with it. If it is true as I have tried to show that love is the only sane and satisfactory response to the problem of human existence, then any society which excludes, relatively, the development of love, must in the long run perish of its own contradiction with the basic necessities of human nature. Indeed, to speak of love is not 'preaching,' for the simple reason that it means to speak of the ultimate and real need in every human being. . . . To have faith in the possibility of love as a social and not only exceptional-individual phenomenon, is a rational faith based on the insight into the very nature of man." Faith enables us to move past fear. We can collectively regain our faith in the transformative power of love by cultivating courage, the strength to stand up for what we believe in, to be accountable both in word and deed.

I am especially fond of the biblical passage in the first epistle of John, which tells us: "There is no fear in love; but perfect love casteth out fear: because fear hath torment. He that feareth is not made perfect in love." From childhood on this passage of scripture has enchanted me. I was fascinated by the repeated use of the word "perfect." For some time I thought of this word only in relation to being without fault or defect. Taught to believe that this understanding of what it means to be perfect was always out of human reach, that we were, of necessity, essentially human because we were not perfect but were always bound by the mystery of the body, by our limitations, this

call to know a perfect love disturbed me. It seemed a worthy calling, but impossible. That is, until I looked for a deeper, more complex understanding of the word "perfect" and found a definition emphasizing the will "to refine."

Suddenly my passage was illuminated. Love as a process that has been refined, alchemically altered as it moves from state to state, is that "perfect love" that can cast out fear. As we love, fear necessarily leaves. Contrary to the notion that one must work to attain perfection, this outcome does not have to be struggled for—it just happens. It is the gift perfect love offers. To receive the gift, we must first understand that "there is no fear in love." But we do fear and fear keeps us from trusting in love.

Cultures of domination rely on the cultivation of fear as a way to ensure obedience. In our society we make much of love and say little about fear. Yet we are all terribly afraid most of the time. As a culture we are obsessed with the notion of safety. Yet we do not question why we live in states of extreme anxiety and dread. Fear is the primary force upholding structures of domination. It promotes the desire for separation, the desire not to be known. When we are taught that safety lies always with sameness, then difference, of any kind, will appear as a threat. When we choose to love we choose to move against fear—against alienation and separation. The choice to love is a choice to connect—to find ourselves in the other.

Since so many of us are imprisoned by fear, we can

move toward a love ethic only by the process of conversion. Philosopher Cornel West states that "a politics of conversion" restores our sense of hope. Calling attention to the pervasive nihilism in our society he reminds us: "Nihilism is not overcome by arguments or analyses, it is tamed by love and care. Any disease of the soul must be conquered by a turning of one's soul. This turning is done through one's own affirmation of one's worth—an affirmation fueled by the concern of others." In an attempt to ward off life-threatening despair, more and more individuals are turning toward a love ethic. Signs that this conversion is taking place abound in our culture. It's reassuring when masses of people read literature like Thomas Moore's *Care of the Soul,* a work that invites us to reevaluate the values that undergird our lives and make choices that affirm our interconnectedness with others.

Embracing a love ethic means that we utilize all the dimensions of love—"care, commitment, trust, responsibility, respect, and knowledge"—in our everyday lives. We can successfully do this only by cultivating awareness. Being aware enables us to critically examine our actions to see what is needed so that we can give care, be responsible, show respect, and indicate a willingness to learn. Understanding knowledge as an essential element of love is vital because we are daily bombarded with messages that tell us love is about mystery, about that which cannot be known. We see movies in which people are represented

as being in love who never talk with one another, who fall into bed without ever discussing their bodies, their sexual needs, their likes and dislikes. Indeed, the message received from the mass media is that knowledge makes love less compelling; that it is ignorance that gives love its erotic and transgressive edge. These messages are often brought to us by profiteering producers who have no clue about the art of loving, who substitute their mystified visions because they do not really know how to genuinely portray loving interaction.

Were we, collectively, to demand that our mass media portray images that reflect love's reality, it would happen. This change would radically alter our culture. The mass media dwells on and perpetuates an ethic of domination and violence because our image makers have more intimate knowledge of these realities than they have with the realities of love. We all know what violence looks like. All scholarship in the field of cultural studies focusing on a critical analysis of the mass media, whether pro or con, indicates that images of violence, particularly those that involve action and gore, capture the attention of viewers more than still, peaceful images. The small groups of people who produce most of the images we see in this culture have heretofore shown no interest in learning how to represent images of love in ways that will capture and stir our cultural imagination and hold our attention.

If the work they did was informed by a love ethic, they

would consider it important to think critically about the images they create. And that would mean thinking about the impact of these images, the ways they shape culture and inform how we think and act in everyday life. If unfamiliar with love's terrain, they would hire consultants who would provide the necessary insight. Even though some individual scholars try to tell us there is no direct connection between images of violence and the violence confronting us in our lives, the commonsense truth remains—we are all affected by the images we consume and by the state of mind we are in when watching them. If consumers want to be entertained, and the images shown us as entertaining are images of violent dehumanization, it makes sense that these acts become more acceptable in our daily lives and that we become less likely to respond to them with moral outrage or concern. Were we all seeing more images of loving human interaction, it would undoubtedly have a positive impact on our lives.

We cannot talk about changing the types of images offered us in the mass media without acknowledging the extent to which the vast majority of the images we see are created from a patriarchal standpoint. These images will not change until patriarchal thinking and perspectives change. Individual women and men who do not see themselves as victims of patriarchal power find it difficult to take seriously the need to challenge and change patriarchal thinking. But reeducation is always possible. Masses of

people are negatively affected by patriarchal institutions and, most specifically, by male domination. Since individuals committed to advancing patriarchy are producing most of the images we see, they have an investment in providing us with representations that reflect their values and the social institutions they wish to uphold. Patriarchy, like any system of domination (for example, racism), relies on socializing everyone to believe that in all human relations there is an inferior and a superior party, one person is strong, the other weak, and that it is therefore natural for the powerful to rule over the powerless. To those who support patriarchal thinking, maintaining power and control is acceptable by whatever means. Naturally, anyone socialized to think this way would be more interested in and stimulated by scenes of domination and violence rather than by scenes of love and care. Yet they need a consumer audience to whom they can sell their product. Therein lies our power to demand change.

While the contemporary feminist movement has done much to intervene with this kind of thinking, challenging and changing it, and by so doing offering women and men a chance to lead more fulfilling lives, patriarchal thinking is still the norm for those in power. This does not mean we do not have the right to demand change. We have power as consumers. We can exercise that power all the time by not choosing to invest time, energy, or funds to support the production and dissemination of mass media

images that do not reflect life-enhancing values, that undermine a love ethic. This is not meant to be an argument for censorship. Most of the evils in our world are not created by the mass media. For example, clearly, the mass media does not create violence in the home. Domestic violence was widespread even when there was no television. But everyone knows that all forms of violence are glamorized and made to appear interesting and seductive by the mass media. The producers of these images could just as easily use the mass media to challenge and change violence. When images we see condone violence, whether they lead any of us to be "more" violent or not, they do affirm the notion that violence is an acceptable means of social control, that it is fine for one individual or group to dominate another individual or group.

Domination cannot exist in any social situation where a love ethic prevails. Jung's insight, that if the will to power is paramount love will be lacking, is important to remember. When love is present the desire to dominate and exercise power cannot rule the day. All the great social movements for freedom and justice in our society have promoted a love ethic. Concern for the collective good of our nation, city, or neighbor rooted in the values of love makes us all seek to nurture and protect that good. If all public policy was created in the spirit of love, we would not have to worry about unemployment, homelessness, schools failing to teach children, or addiction.

Were a love ethic informing all public policy in cities and towns, individuals would come together and map out programs that would affect the good of everyone. Melody Chavis's wonderful book *Altars in the Street: A Neighborhood Fights to Survive* tells a story of real people coming together across differences of race and class to improve their living environment. She speaks from the perspective of a white woman who moves with her family into a predominately black community. As someone who embraces a love ethic, Melody joins her neighbors to create peace and love in their environment. Their work succeeds but is undermined by the failure of support from public policy and city government. Concurrently, she also works to help prisoners on death row. Loving community in all its diversity, Melody states: "Sometimes I think that I've been trying, on death row and in my neighborhood, to gain some control over the violence in my life. As a child I was completely helpless in the face of violence." Her book shows the changes a love ethic can make even in the most troubled community. It also documents the tragic consequences to human life when terror and violence become the accepted norm.

When small communities organize their lives around a love ethic, every aspect of daily life can be affirming for everyone. In all his prose work Kentucky poet Wendell Berry writes eloquently about the positive values that exist in rural communities that embrace an ethic of commu-

nalism and the sharing of resources. In *Another Turn of the Crank,* Berry exposes the extent to which the interests of big business lead to the destruction of rural communities, reminding us that destruction is fast becoming the norm in all types of communities. He encourages us to learn from the lives of folks who live in communities governed by a spirit of love and communalism. Sharing some of the values held by citizens of these communities he writes: "They are people who take and hold a generous and neighborly view of self-preservation; they do not believe that they can survive and flourish by the rule of dog eat dog; they do not believe that they can succeed by defeating or destroying or selling or using up everything but themselves. They doubt that good solutions can be produced by violence. They want to preserve the precious things of nature of human culture and pass them on to their children. . . . They see that no commonwealth or community of interest can be defined by greed. . . . They know that work ought to be necessary; it ought to be good; it ought to be satisfying and dignifying to the people who do it; and genuinely useful and pleasing to the people for whom it is done."

I like living in small towns precisely because they are most often the places in our nation where basic principles underlying a love ethic exist and are the standards by which most people try to live their lives. In the small town where I live (now only some of the time) there is a spirit

of neighborliness—of fellowship, care, and respect. These same values existed in the neighborhoods of the town in which I grew up. Even though I spend most of my time in New York City, I live in a cooperative apartment building where we all know each other. We protect and nurture our collective well-being. We strive to make our home place a positive environment for everyone. We all agree that integrity and care enhance all our lives. We try to live by the principles of a love ethic.

To live our lives based on the principles of a love ethic (showing care, respect, knowledge, integrity, and the will to cooperate), we have to be courageous. Learning how to face our fears is one way we embrace love. Our fear may not go away, but it will not stand in the way. Those of us who have already chosen to embrace a love ethic, allowing it to govern and inform how we think and act, know that when we let our light shine, we draw to us and are drawn to other bearers of light. We are not alone.

Seven

GREED:

SIMPLY LOVE

The fading away of greed and hatred is the foundation for liberation. Liberation is "the sure heart's release"—an understanding of the truth so powerful that there is no turning back from it.

—SHARON SALZBERG

ALTHOUGH WE LIVE in close contact with neighbors, masses of people in our society feel alienated, cut off, alone. Isolation and loneliness are central causes of depression and despair. Yet they are the outcome of life in a culture where things matter more than people. Materialism creates a world of narcissism in which the focus of life is solely on acquisition and consumption. A culture of narcissism is not a place where love can flourish. The emergence of the "me" culture is a direct response to our nation's failure to truly actualize the vision of democracy articulated in our Constitution and Bill of Rights. Left alone in the "me" culture, we consume and consume with no thought of others. Greed and exploitation become the norm when an ethic of domination prevails. They bring in their wake alienation and lovelessness. Intense spiritual and emotional lack in our lives is the perfect breeding ground for material greed and overconsumption. In a

world without love the passion to connect can be replaced by the passion to possess. While emotional needs are difficult, and often are impossible to satisfy, material desires are easier to fulfill. Our nation fell into the trap of pathological narcissim in the wake of wars that brought economic bounty while undermining the vision of freedom and justice essential to sustaining democracy.

Nowadays we live in a world where poor teenagers are willing to maim and murder for a pair of tennis shoes or a designer coat; this is not a consequence of poverty. In dire situations of poverty at earlier times in our nation's history, it would have been unthinkable to the poor to murder someone for a luxury item. While it was common for individuals to steal or attack someone in the interests of acquiring resources—money, food, or something as simple as a winter coat to ward off the cold—there was no value system in place that made a life less important than the material desire for an inessential object.

Whether poor or rich, in the mid-fifties most citizens in our nation felt it was the best place in the world to live because it was a democracy, a place where human rights mattered. This sense of our nation's vision sustained its citizens and served as the catalyst empowering freedom struggles in our society. In the article "Chicken Little, Cassandra, and the Real Wolf: So Many Ways to Think About the Future," Donella Meadows describes the significance of a visionary standpoint: "A vision articulates

a future that someone deeply wants, and does it so clearly and compellingly that it summons up the energy, agreement, sympathy, political will, creativity, resources, or whatever to make that vision happen." Our nation's active participation in global warfare called into question its commitment to democracy both here at home and abroad.

That vision was diminished in the wake of the Vietnam War. Prior to the war, a hopeful vision of justice and love had been evoked by the civil rights struggle, the feminist movement, and sexual liberation. However, by the late seventies, after the failure of radical movements for social justice aimed at making the world a democratic, peaceful place where resources could be shared and a meaningful life could become a possibility for everyone, folks stopped talking about love. The loss of lives at home and abroad had created economic plenty while leaving in its wake devastation and loss. Americans were asked to sacrifice the vision of freedom, love, and justice and put in its place the worship of materialism and money. This vision of society upheld the need for imperialistic war and injustice. A great feeling of despair gripped our nation when the leaders who had led struggles for peace, justice, and love were assassinated.

Psychologically, we were in despair even as economic booms opened up jobs for women and men from previously disenfranchised groups. Instead of looking for justice in the public world, individuals turned to their pri-

vate lives, seeking a place of solace and escape. Initially, lots of folks turned inward to family and relationships to find again a sense of connection and stability. Coming face to face with rampant lovelessness in the home created an overwhelming sense of cultural brokenheartedness. Not only did individuals despair about their capacity to change the world, they began to feel enormous despair about their ability to make basic positive changes in the emotional fabric of their daily lives. Divorce rates were the primary indicators that marriage was not a safe haven. And mounting public awareness of the extent to which domestic violence and all manner of child abuse were widespread clearly revealed that the patriarchal family could not offer sanctuary.

Confronted with a seemingly unmanageable emotional universe, some people embraced a new Protestant work ethic, convinced that a successful life would be measured by how much money one made and the goods one could buy with this money. The good life was no longer to be found in community and connection, it was to be found in accumulation and the fulfillment of hedonistic, materialistic desire. In keeping with this shift in values from a people-oriented to a thing-oriented society, the rich and famous, particularly movie stars and singers, began to be seen as the only relevant cultural icons. Gone were the visionary political leaders and activists. Suddenly it was no longer important to bring an ethical dimension to the

work life, making money was the goal, and by whatever means. Widespread embrace of corruption undermined any chance that a love ethic would resurface and restore hope.

By the late seventies, among privileged people the worship of money was expressed by making corruption acceptable and the ostentatious parading of material luxury the norm. To many people, our nation's acceptance of corruption as the new order of the day began with the unprecedented exposure of presidential dishonesty and the lack of ethical and moral behavior in the White House. This lack of ethics was explained away by government officials linking support of big business to further imperialism with national security and dominance globally. This coincided neatly with the decline in the influence of institutionalized religion, which had previously provided moral guidance. The church and temple became places where a materialistic ethic was supported and rationalized.

Among the poor and the other underclasses, the worship of money became most evident by the unprecedented increase in the street drug industry, one of the rare locations where capitalism worked well for a few individuals. Quick money, often large amounts made from drug sales, allowed the poor to satisfy the same material longings as the rich. While the desired objects might have differed, the satisfaction of acquisition and possession was the same.

Greed was the order of the day. Mirroring the dominant capitalist culture, a few individuals in poor communities prospered while the vast majority suffered endless unsatisfied cravings. Imagine a mother living in poverty who has always taught her children the difference between right and wrong, who has taught them to value being honest because she wants to provide them with a moral and ethical universe, who suddenly accepts a child selling drugs because it brings into the home financial resources for both necessary and unnecessary expenses. Her ethical values are eroded by the intensity of longing and lack. But she no longer sees herself as living at odds with the consumer culture she lives in; she has become connected, one with the culture of consumption and driven by its demands.

Love is not a topic she thinks about. Her life has been characterized by a lack of love. She has found it makes life easier when she hardens her heart and turns her attention toward more attainable goals—acquiring shelter and food, making ends meet, and finding ways to satisfy desires for little material luxuries. Thinking about love may simply cause her pain. She, and hordes of women like her, have had enough pain. She may even turn to addiction to experience the pleasure and satisfaction she never found when seeking love.

Widespread addiction in both poor and affluent communities is linked to our psychotic lust for material con-

sumption. It keeps us unable to love. Fixating on wants and needs, which consumerism encourages us to do, promotes a psychological state of endless craving. This leads to an anguish of spirit and torment so intense that intoxicating substances provide release and relief while bringing in their wake the problem of addiction. Millions of our nation's citizens are addicted to alcohol and legal and illegal drugs. In poor communities, where addiction is the norm, there is no culture of recovery. The poor who are addicted and who lack the means to indulge their habit are caught in the grip of major physical and emotional suffering. Addicts want release from pain; they are not thinking about love.

In Stanton Peele's useful book *Love and Addiction,* he makes the insightful point that "addiction is not about relatedness." Addiction makes love impossible. Most addicts are primarily concerned with acquiring and using their drug, whether it be alcohol, cocaine, heroin, sex, or shopping. Hence, addiction is both a consequence of widespread lovelessness and a cause. Only the drug is sacred to an addict. Relationships of intimacy and closeness are destroyed as the addicted individual participates in a greedy search for satisfaction. Greed characterizes the nature of this pursuit because it is unending; the desire is ongoing and can never be fully satisfied.

Of course, the ravages of addiction are more glaringly obvious in the lives of the poor and dispossessed because

they have neither the means to engage in the cover-ups so effectively employed by privileged addicts nor the access to recovery programs. When the case against O. J. Simpson was national news, there was little discussion of the role substance abuse played in facilitating the emotional estrangement in an already dysfunctional family. While domestic violence was highlighted, and everyone agrees that it was not acceptable behavior, substance abuse was not. It was not seen as a major factor that destroyed the conditions needed for positive emotional interaction.

For example, it was not acceptable for anyone to talk compassionately (in a manner that did not blame the victim) about the possibility that Nicole Simpson had kept herself and her children in a dangerous, life-threatening environment in part because she was not willing to sacrifice her attachment to a superficially glamorous lifestyle among the rich and famous. Behind the scenes, when they are not afraid of being seen as politically incorrect, women who are bonded with abusive, rich, and powerful men talk easily about their addiction to power and wealth. Both men and women remain in dysfunctional, loveless relationships when it is materially opportune.

All over this nation greed motivates individuals to place themselves in life-threatening situations. Our prisons are full of people whose crimes were motivated by greed, usually the lust for money. While this lust is the natural response of anyone who has totally embraced the values of

consumerism, when these individuals harm others in their pursuit of wealth we are encouraged to see their behavior as aberrant. We are all encouraged to believe they are not like us, yet studies show that many people are willing to lie to gain monetary advantage. Most people are tempted by longings to endlessly consume or to try to acquire wealth by any means. In recent years the public support of gambling, both in lotteries and casinos, has heightened the awareness that desire for money can be addictive. Yet the fact that large numbers of working- and middle-class people gamble away their hard-earned incomes in the hope of becoming wealthy is never national news. Many of these hardworking citizens lie and cheat other family members to sustain their habit. While they will not be arrested or put in prison, their dysfunctional behavior undermines the trust and care in families. They have more in common with prisoners who risk everything in the hope of making easy money than they have with family members who want loving connection to be more important than the lust for material success.

In the *Seven Laws of Money,* Michael Phillips calls attention to the fact that most of the prisoners he encountered, incarcerated for stealing as they attempted to "get rich quick," were smart, industrious individuals who could have worked and attained material wealth. Working daily to earn money would have taken time. Significantly, the combination of the lust for material wealth and the

desire for immediate satisfaction are the signs that this materialism has become addictive. The need for instant gratification is a component of greed.

This same politics of greed is at play when folks seek love. They often want fulfillment immediately. Genuine love is rarely an emotional space where needs are instantly gratified. To know genuine love we have to invest time and commitment. As John Welwood reminds us in *Journey of the Heart: The Path of Conscious Love,* "dreaming that love will save us, solve all our problems or provide a steady state of bliss or security only keeps us stuck in wishful fantasy, undermining the real power of the love—which is to transform us." Many people want love to function like a drug, giving them an immediate and sustained high. They want to do nothing, just passively receive the good feeling. In patriarchal culture men are especially inclined to see love as something they should receive without expending effort. More often than not they do not want to do the work that love demands. When the practice of love invites us to enter a place of potential bliss that is at the same time a place of critical awakening and pain, many of us turn our backs on love.

All the widespread emphasis on dysfunctional relationships in our society could easily lead to the assumption that we are a nation committed to ending dysfunction, committed to creating a culture where love can flourish. The truth is, we are a nation that normalizes dysfunction.

The more attention focused on dysfunctional bonds, the more the message that families are all a bit messed up becomes commonplace and the greater the notion becomes that this is just how families are. Like hedonistic consumption, we are encouraged to believe that the excesses of the family are normal and that it is abnormal to believe that one can have a functional, loving family.

This is the outcome of living in a culture where the politics of greed are normalized. The message we get is that everybody wants to have more money to buy more things so it is not problematic if we lie and cheat a bit to get ahead. Unlike love, desires for material objects can be satisfied instantly if we have the cash or the credit card handy, or even if we are just willing to sign the papers that make it so we can get what we want now and pay more later. Concurrently, when it comes to matters of the heart we are encouraged to treat partners as though they were objects we can pick up, use, and then discard and dispose of at will, with the one criteria being whether or not individualistic desires are satisfied.

When greedy consumption is the order of the day, dehumanization becomes acceptable. Then, treating people like objects is not only acceptable but is required behavior. It's the culture of exchange, the tyranny of marketplace values. Those values inform attitudes about love. Cynicism about love leads young adults to believe there is no love to be found and that relationships are needed only to

the extent that they satisfy desires. How many times do we hear someone say "Well, if that person is not satisfying your needs you should get rid of them"? Relationships are treated like Dixie cups. They are the same. They are disposable. If it does not work, drop it, throw it away, get another. Committed bonds (including marriage) cannot last when this is the prevailing logic. And friendships or loving community cannot be valued and sustained.

Most of us are unclear about what to do to protect and strengthen caring bonds when our self-centered needs are not being met. Most people wish they could find love where they are, in the lives and relationships they have chosen, but they feel they lack useful strategies for maintaining these bonds. They turn to mass media for answers. Increasingly, the mass media is the primary vehicle for the promotion and affirmation of greed; there is little information offered about the establishment and maintenance of meaningful relationships. If the will to accumulate is not already present in the television watcher or the moviegoer, it will be implanted by images that bombard the psyche with the message that consuming with others, not connection, should be our goal. Nowadays we go to a movie and must watch commercials first. The relaxed, receptive state of surrender we like to reserve for the pleasure of entering into the aesethic space of a film in a dark theater is now given over to advertising, where our sense and our sensibilities are assaulted against our will.

Greed is rightly considered a "deadly sin" because it erodes the moral values that encourage us to care for the common good. Greed violates the spirit of connectedness and community that is natural to human survival. It wipes out individual recognition of the needs and concerns of everyone, replacing this awareness with harmful self-centeredness. Healthy narcissim (the self-acceptance, self-worth, that is the cornerstone of self-love) is replaced by a pathological narcissism (wherein only the self matters) that justifies any action that enables the satisfying of desires. The will to sacrifice on behalf of another, always present when there is love, is annihilated by greed. No doubt this explains our nation's willingness to deprive poor citizens of government-funded social services while huge sums of money fuel the ever-growing culture of violent imperialism. The profiteering prophets of greed are never content; it is not enough for this country to be consumed by a politics of greed, it must become the natural way of life globally.

Generosity and charity militates against the proliferation of greed, whether it takes the form of kindness to one's neighbor, creating a progressive system of job sharing, or supporting state-funded welfare programs. When the politics of greed become a cultural norm, all acts of charity are wrongly seen as suspect and are represented as a gesture of the weak. As a consequence, our nation's citizens become less charitable every day, arrogantly defending self-serving policies, which protect the interests of the

rich, by claming that the poor and needy have not worked hard enough. I have been astonished by hearing individuals who inherited wealth in childhood warn against sharing resources because people needing help should work for money in order to appreciate its value. Inherited wealth and/or substantial material resources are rarely talked about in the mass media because those who receive it do not wish to validate the idea that money received that is not a reward for hard work is beneficial. Their acceptance and use of this money to strengthen their economic self-sufficiency exposes the reality that working hard is rarely the means by which enough of us can gain enough access to material resources to become wealthy. One of the ironies of the culture of greed is that the people who profit the most from earnings they have not worked to attain are the most eager to insist that the poor and working classes can only value material resources attained through hard work. Of course, they are merely establishing a belief system that protects their class interests and lessens their accountability to those who are without privilege.

Marianne Williamson addresses the widespread cynicism about the sharing of resources, which threatens the spiritual well-being of our nation, in *The Healing of America*. Williamson contends: "There is so much injustice in America, and such a conspiracy not to discuss it; and so much suffering, and so much deflection lest we notice. We are told that these problems are secondary, or

that it would cost too much to fix them—as though money is what matters most. Greed is considered legitimate now, while brotherly love is not." Although Williamson is a New Age guru, her courageous willingness to talk about the unacceptable did not diminish her popularity, most readers simply chose to overlook this particular book. In it she challenges us to resist, to dare to change injustice. Without denying that she is privileged, she calls herself and us to task for not sharing the wealth.

Everyone finds it difficult to resist the dictates of greed. Letting go of material desires may compel us to enter the space where our emotional wants are exposed. When I interviewed popular rap artist Lil' Kim, I found it fascinating that she had no interest in love. While she spoke articulately about the lack of love in her life, the topic that most galvanized her attention was making money. I came away from our discussion awed by the reality that a young black female from a broken home, with less than a high school education, could struggle against all manner of barriers and accumulate material riches yet be without hope that she could overcome the barriers blocking her from knowing how to give and receive love.

The culture of greed validates and legitimizes her worship of money; it is not at all interested in her emotional growth. Who cares if she ever knows love? Sadly, like so many Americans, she believes that the pursuit and attainment of wealth will compensate for all emotional lack.

Like so many of our nation's citizens, she does not pay close attention to the mass media messages that tell us about the emotional suffering of the rich. If money really made up for loss and lovelessness, the wealthy would be the most blissful people on the planet. Instead, we would do well to remember again the prophetic lyrics sung by the Beatles: "Money can't buy me love."

Ironically, the rich who grow greedier and overprotective of their wealth are increasingly as perpetually stressed and dissatisfied as the greedy poor who suffer endless cravings. The rich cannot get enough; they cannot find contentment. Yet everyone wants to emulate the rich. In *Freedom of Simplicity,* Richard Foster writes: "Think of the misery that comes into our lives by our restless gnawing greed. We plunge ourselves into enormous debt and then take two and three jobs to stay afloat. We uproot our families with unnecessary moves just so we can have a more prestigious house. We grasp and grab and never have enough. And most destructive of all, our flashy cars and sport spectaculars and backyard pools have a way of crowding out much interest in civil rights or inner city poverty or the starved masses of India. Greed has a way of severing the cords of compassion." Indeed, we ignore the starving masses in *this* society, the thirty-eight million poor people whose lives are testimony to our nation's failure to share resources in a charitable and equitable manner. The worship of money leads to a hardening of the

heart. And it can lead any of us to condone, either actively or passively, the exploitation and dehumanization of ourselves and others.

Much has been made of the fact that so many sixties radicals went on to become hardcore capitalists, profiting by the system they once critiqued and wanted to destroy. But no one assumes responsiblity for the shift in values that made the peace and love culture turn toward the politics of profit and power. That shift came about because the free love that flourished in utopian communal hippie enclaves, where everyone was young and carefree, did not take root in the daily lives of ordinary working and retired people. Young progressives committed to social justice who had found it easy to maintain radical politics when they were living on the edge, on the outside, did not want to do the hard work of changing and reorganizing our existing system in ways that would affirm the values of peace and love, or democracy and justice. They fell into despair. And that despair made capitulation to the existing social order the only place of comfort.

It did not take long for this generation to find out that they loved material comfort more than justice. It was one thing to spend a few years doing without comfort to fight for justice, for civil rights for nonwhite people and women of all races, but it was quite another to consider a lifetime where one might face material lack or be compelled to share resources. When many of the radicals and/or hippies

who had rebelled against excess privilege began to raise children, they wanted them to have the same access to material privilege they had known—as well as the luxury of rebelling against it; they wanted them to be materially secure. Concurrently, many of the radicals and/or hippies who had come from backgrounds of material lack were also eager to find a world of material plenty that would sustain them. Everyone feared that if they continued to support a vision of communalism, of sharing resources, that they would have to make do with less.

Lately, I have sat around dinner tables, with fancy food and drink, dismayed as I listen to reformed radicals joke about the fact that they would never have imagined years ago that they would become "social liberals and fiscal conservatives," people who want to end welfare while promoting and supporting big business. Williamson makes this insightful point: "The backlash against welfare in America today is not really a backlash against welfare abuse, so much as it is a backlash against compassion in the public sphere. While America is full of those who would police our private morals, there is far too little questioning of societal morals. We are among the richest nation on earth, yet we spend a trivial amount on our poor compared to that spent by every other Western industrialized nation. One fifth of America's children live in poverty. Half of our African-American children live in

poverty. We are the only industrialized Western nation that does not have universal health care." These are the truths no one wants to face. Many of our nation's citizens are afraid to embrace an ethics of compassion because it threatens their security. Brainwashed to believe that they can only be secure if they have more than the next person, they accumulate and *still* feel insecure because there is always someone who has accumulated more.

WE ARE ALL witnessing the ever-widening gap between the rich and the poor, between the haves and the have-nots. Those with class privilege live in neighborhoods where affluence and abundance are made explicit and are celebrated. The hidden cost of that affluence is not apparent, however. We need not witness the suffering of the many so that the few may live in a world of excessive luxury. I once asked a rich man, who had only recently attained his status, what he liked most about his new wealth. He said that he liked seeing what money could make people do, how it could make them shift and violate their values. He personified the culture of greed. His pleasure in being wealthy was grounded in the desire to not only have more than others but to use that power to degrade and humiliate them. To maintain and satisfy greed, one must support domination. And the world of domination is always a world without love.

* * *

WE ARE ALL vulnerable. We have all been tempted. Even those of us committed to an ethic of love are sometimes tempted by greedy desires. These are dangerous times. It is not just the corrupt who fall sway to greed. Individuals with good intentions and kind hearts can be swept away by unprecedented access to power and privilege. When our president exploits his power and consensually seduces a young woman in the government's employ, he gives public expression to this greed. His actions reveal a willingness to place all he holds dear at risk for the satisfaction of hedonistic pleasure. That so many of our nation's citizens felt his misuse of power was simply the way things are done—that he simply had the misfortune to get caught—is further testimony that the politics of greed are condoned. They exemplify the greedy mindset that threatens to consume our capacity to love and with it our capacity to sacrifice on behalf of those we love. Concurrently, the young woman involved manipulates facts and details, and ultimately prostitutes herself by selling her story for material gain because she is greedy for fame and money, and society condones this get-rich-quick scheme. Her greed is even more intense because she also wants to be seen as a victim. With the boldness of any con artist working the capitalist addiction to fantasy, she attempts to rewrite the script of their consensual exchange of pleasure so that it can appear to be a love story. Her

hope is that everyone will be seduced by the fantasy and will ignore the reality that deceit, betrayal, and a lack of care for the feelings of others can never be a place where love will flourish. This is a not a love story. It is a public dramatization of the politics of greed at play, a greed so intense it destroys love.

Greed subsumes love and compassion; living simply makes room for them. Living simply is the primary way everyone can resist greed every day. All over the world people are becoming more aware of the importance of living simply and sharing resources. While communism has suffered political defeat globally, the politics of communalism continue to matter. We can all resist the temptation of greed. We can work to change public policy, electing leaders who are honest and progressive. We can turn off the television set. We can show respect for love. To save our planet we can stop thoughtless waste. We can recycle and support ecologically advanced survival strategies. We can celebrate and honor communalism and interdependency by sharing resources. All these gestures show a respect and a gratitude for life. When we value the delaying of gratification and take responsibility for our actions, we simplify our emotional universe. Living simply makes loving simple. The choice to live simply necessarily enhances our capacity to love. It is the way we learn to practice compassion, daily affirming our connection to a world community.

COMMUNITY:
LOVING COMMUNION

Community cannot take root in a divided life. Long before community assumes external shape and form, it must be present as a seed in the undivided self: only as we are in communion with ourselves can we find community with others.

—PARKER PALMER

To ENSURE HUMAN survival everywhere in the world, females and males organize themselves into communities. Communities sustain life—not nuclear families, or the "couple," and certainly not the rugged individualist. There is no better place to learn the art of loving than in community. M. Scott Peck begins his book *The Different Drum: Community Making and Peace* with the profound declaration: "In and through community lies the salvation of the world." Peck defines community as the coming together of a group of individuals "who have learned how to communicate honestly with each other, whose relationships go deeper than their masks of composure, and who have developed some significant commitment to 'rejoice together, mourn together,' and to 'delight in each other, and make other's conditions our own.'" We are all born into the world of community. Rarely if ever does a child come into the world in isola-

tion, with only one or two onlookers. Children are born into a world surrounded by the possibility of communities. Family, doctors, nurses, midwives, and even admiring strangers comprise this field of connections, some more intimate than others.

Much of the talk about "family values" in our society highlights the nuclear family, one that is made up of mother, father, and preferably only one or two children. In the United States this unit is presented as the primary and preferable organization for the parenting of children, one that will ensure everyone's optimal well-being. Of course, this is a fantasy image of family. Hardly anyone in our society lives in an environment like this. Even individuals who are raised in nuclear families usually experience it as merely a small unit within a larger unit of extended kin. Capitalism and patriarchy together, as structures of domination, have worked overtime to undermine and destroy this larger unit of extended kin. Replacing the family community with a more privatized small autocratic unit helped increase alienation and made abuses of power more possible. It gave absolute rule to the father, and secondary rule over children to the mother. By encouraging the segregation of nuclear families from the extended family, women were forced to become more dependent on an individual man, and children more dependent on an individual woman. It is this dependency that became, and is, the breeding ground for abuses of power.

The failure of the patriarchal nuclear family has been utterly documented. Exposed as dysfunctional more often than not, as a place of emotional chaos, neglect, and abuse, only those in denial continue to insist that this is the best environment for raising children. While I do not want to suggest that extended families are not as likely to be dysfunctional, simply by virtue of their size and their inclusion of nonblood kin (i.e., individuals who marry into the family and their blood relations), they are diverse and so are likely to include the presence of some individuals who are both sane and loving.

When I first began to speak publicly about my dysfunctional family, my mother was enraged. To her, my achievements were a sign that I could not have suffered "that much" in our nuclear family. Yet I know I survived and thrived despite the pain of childhood precisely because there were loving individuals among our extended family who nurtured me and gave me a sense of hope and possibility. They showed that our family's interactions did not constitute a norm, that there were other ways to think and behave, different from the accepted patterns in our household. This story is common. Surviving and triumphing over dysfunctional nuclear families may depend on the presence of what psychoanalyst Alice Miller calls "enlightened witnesses." Practically every adult who experienced unnecessary suffering in childhood has a story to tell about someone whose kindness, tenderness, and

concern restored their sense of hope. This could only happen because families existed as part of larger communities.

The privatized patriarchal nuclear family is still a fairly recent form of social organization in the world. Most world citizens do not have, and will never have, the material resources to live in small units segregated from larger family communities. In the United States studies show that economic factors (the high cost of housing, unemployment) are swiftly creating a cultural climate in which grown children are leaving the family home later, and are frequently returning or never leaving in the first place. Research by anthropologists and sociologists indicates that small privatized units, especially those organized around patriarchal thinking, are unhealthy environments for everyone. Globally, enlightened, healthy parenting is best realized within the context of community and extended family networks.

The extended family is a good place to learn the power of community. However, it can only become a community if there is honest communication between the individuals in it. Dysfunctional extended families, like smaller nuclear family units, are usually characterized by muddied communication. Keeping family secrets often makes it impossible for extended groups to build community. There was once an advertisement that used the slogan "The family that prays together stays together." Since prayer is one way to communicate, it no doubt does help family mem-

bers stay connected. I remember hearing this slogan as a teenager, usually in situations where authority figures were coercing us to pray, and changing it to "The family that talks together stays together." Talking together is one way to make community.

IF WE DO not experience love in our extended families of origin (which is the first site for community offered us), the other place where children in particular have the opportunity to build community and know love is in friendship. Since we choose our friends, many of us, from childhood on into our adulthood, have looked to friends for the care, respect, knowledge, and all-around nurturance of our growth that we did not find in the family. Writing in her moving memoir *Never Let Me Down,* Susan Miller recalls: "I kept thinking, love must be here, somewhere. I looked and looked inside myself, but I couldn't find it. I knew what love was. It was the feeling I had for my dolls, for beautiful things, for certain friends. Later on, when I knew Debbie, my best friend, I felt even more sure that love was what made you feel good. Love was not what made you feel bad, hate yourself. It was what comforted you, freed you up inside, made you laugh. Sometimes Debbie and I would fight, but that was different because we were basically, essentially connected." Loving friendships provide us with a space to experience the joy of community in a relationship where we learn to

process all our issues, to cope with differences and conflict while staying connected.

Most of us are raised to believe we will either find love in our first family (our family of origin) or, if not there, in the second family we are expected to form through committed romantic couplings, particularly those that lead to marriage and/or lifelong bondings. Many of us learn as children that friendship should never be seen as just as important as family ties. However, friendship is the place in which a great majority of us have our first glimpse of redemptive love and caring community. Learning to love in friendships empowers us in ways that enable us to bring this love to other interactions with family or with romantic bonds. A dear friend's mother died when she was just a young adult. Once when I was complaining about my mother fussing at me, she shared that she would give anything to hear her mother's voice scolding her. Encouraging me to be patient with my mother, she spoke of the pain of losing her mother and wished they had worked harder to find a place of communication and reconciliation. Her words reminded me to be compassionate, to focus on what I really enjoy about my mother. In friendship we are able to hear honest, critical feedback. We trust that a true friend desires our good. My friend wants me to relish the presence of my mother.

Often we take friendships for granted even when they are the interactions where we experience mutual pleasure.

We place them in a secondary position, especially in relation to romantic bonds. This devaluation of our friendships creates an emptiness we may not see when we are devoting all our attention to finding someone to love romantically or giving all our attention to a chosen loved one. Committed love relationships are far more likely to become codependent when we cut off all our ties with friends to give these bonds we consider primary our exclusive attention. I have felt especially devastated when close friends who were single fell in love and simultaneously fell away from our friendship. When a best friend chose a mate who did not click with me at all, it caused me heartache. Not only did they begin to do everything together, the friends she stayed closest to were those he liked best.

The strength of our friendship was revealed by our willingness to confront openly the shift in our ties and to make necessary changes. We do not see each other as much as we once did, and we no longer call each other daily, but the positive ties that bind us remain intact. The more genuine our romantic loves the more we do not feel called upon to weaken or sever ties with friends in order to strengthen ties with romantic partners. Trust is the heartbeat of genuine love. And we trust that the attention our partners give friends, or vice versa, does not take anything away from us—we are not diminished. What we learn through experience is that our capacity to establish

deep and profound connections in friendship strengthens all our intimate bonds.

When we see love as the will to nurture one's own or another's spiritual growth, revealed through acts of care, respect, knowing, and assuming responsibility, the foundation of all love in our life is the same. There is no special love exclusively reserved for romantic partners. Genuine love is the foundation of our engagement with ourselves, with family, with friends, with partners, with everyone we choose to love. While we will necessarily behave differently depending on the nature of a relationship, or have varying degrees of commitment, the values that inform our behavior, when rooted in a love ethic, are always the same for any interaction. One of the longest romantic relationships of my life was one in which I behaved in the more traditional manner of placing it above all other interactions. When it became destructive, I found it difficult to leave. I found myself accepting behavior (verbal and physical abuse) that I would not have tolerated in a friendship.

I had been raised conventionally to believe this relationship was "special" and should be revered above all. Most women and men born in the fifties or earlier were socialized to believe that marriages and/or committed romantic bonds of any kind should take precedence over all other relationships. Had I been evaluating my relationship from a standpoint that emphasized growth rather than duty and

obligation, I would have understood that abuse irreparably undermines bonds. All too often women believe it is a sign of commitment, an expression of love, to endure unkindness or cruelty, to forgive and forget. In actuality, when we love rightly we know that the healthy, loving response to cruelty and abuse is putting ourselves out of harm's way. Even though I was a committed feminist as a young woman, all that I knew and believed in politically about equality was, for a time, overshadowed by a religious and familial upbringing that had socialized me to believe everything must be done to save "the relationship."

In retrospect, I see how ignorance about the art of loving placed the relationship at risk from the start. In the more than fourteen years we were together we were too busy repeating old patterns learned in childhood, acting on misguided information about the nature of love, to appreciate the changes we needed to make in ourselves to be able to love someone else. Importantly, like many other women and men (irrespective of sexual preference) who are in relationships where they are the objects of intimate terrorism, I would have been able to leave this relationship sooner or recover myself within it had I brought to this bond the level of respect, care, knowledge, and responsibility I brought to friendships. Women who would no more tolerate a friendship in which they were emotionally and physically abused stay in romantic relationships

where these violations occur regularly. Had they brought to these bonds the same standards they bring to friendship they would not accept victimization.

Naturally, when I left this long-term relationship, which had taken so much time and energy, I was terribly alone and lonely. I learned then that it is more fulfilling to live one's life within a circle of love, interacting with loved ones to whom we are committed. Lots of us learn this lesson the hard way by finding ourselves alone and without meaningful connection to friends. And it has been the experience of both living in fear of abandonment in romantic relationships and being abandoned that has shown us that the principles of love are always the same in any meaningful bond. To love well is the task in all meaningful relationships, not just romantic bonds. I know individuals who accept dishonesty in their primary relationships, or who are themselves dishonest, when they would never accept it in friendships. Satisfying friendships in which we share mutual love provides a guide for behavior in other relationships, including romantic ones. They provide us all with a way to know community.

Within a loving community we sustain ties by being compassionate and forgiving. Eric Butterworth's *Life Is for Loving* includes a chapter on "love and forgiveness." Insightfully he writes: "We cannot endure without love and there is no other way to the return of healing, comforting, harmonizing love than through total and complete

forgiveness: If we want freedom and peace and the experience of love and being loved, we must let go and forgive." Forgiveness is an act of generosity. It requires that we place releasing someone else from the prison of their guilt or anguish over our feelings of outrage or anger. By forgiving we clear a path on the way to love. It is a gesture of respect. True forgiveness requires that we understand the negative actions of another.

While forgiveness is essential to spiritual growth, it does not make everything immediately wonderful or fine. Often, New Age writing on the subject of love makes it seem as though everything will always be wonderful if we are just loving. Realistically, being part of a loving community does not mean we will not face conflicts, betrayals, negative outcomes from positive actions, or bad things happening to good people. Love allows us to confront these negative realities in a manner that is life-affirming and life-enhancing. When a colleague whose work I admired, whom I considered a friend, who for no reason that was ever clear to me, began to write vicious attacks of my work, I was stunned. Her critiques were full of lies and exaggerations. I had been a caring friend. Her actions hurt. To heal this pain I entered into an empathic identification with her so that I could understand what might have motivated her. In *Forgiveness! A Bold Choice for a Peaceful Heart,* Robin Casarjian explains: "Forgiveness is a way of life that gradually transforms us from being help-

less victims of our circumstances to being powerful and loving 'co-creators' of our reality. . . . It is the fading away of the perceptions that cloud our ability to love."

Through the practice of compassion and forgiveness, I was able to sustain my appreciation for her work and cope with the grief and disappointment I felt about the loss of this relationship. Practicing compassion enabled me to understand why she might have acted as she did and to forgive her. Forgiving means that I am able to see her as a member of my community still, one who has a place in my heart should she wish to claim it.

We all long for loving community. It enhances life's joy. But many of us seek community solely to escape the fear of being alone. Knowing how to be solitary is central to the art of loving. When we can be alone, we can be with others without using them as a means of escape. Throughout his life theologian Henri Nouwen emphasized the value of solitude. In many of his books and essays he discouraged us from seeing solitude as being about the need for privacy, sharing his sense that in solitude we find the place where we can truly look at ourselves and shed the false self. In his book *Reaching Out,* he stresses that "loneliness is one of the most universal sources of human suffering today."

Nouwen contends that "no friend or lover, no husband or wife, no community or commune will be able to put to rest our deepest cravings for unity and wholeness."

Wisely, he suggests we put those feelings to rest by embracing our solititude, by allowing divine spirit to reveal itself there: "The difficult road is the road of conversion, the conversion from loneliness into solitude. Instead of running away from our loneliness and trying to forget or deny it, we have to protect it and turn it into fruitful solitude. . . . Loneliness is painful; solitude is peaceful. Loneliness makes us cling to others in desperation; solitude allows us to respect others in their uniqueness and create community." When children are taught to enjoy quiet time, to be alone with their thoughts and reveries, they carry this skill into adulthood. Individuals young and old striving to overcome fears of being alone often choose meditation practice as a way to embrace solitude. Learning how to "sit" in stillness and quietude can be the first step toward knowing comfort in aloneness.

Moving from solitude into community heightens our capacity for fellowship with one another. Through fellowship we learn how to serve one another. Service is another dimension of communal love. At the end of her autobiography *The Wheel of Life*, Elisabeth Kübler-Ross confesses: "I can assure you that the greatest rewards in your whole life will come from opening your heart to those in need. The greatest blessings always come from helping." Women have been and are the world's great teachers about the meaning of service. We publicly honor the memory of exceptional individuals like Mother Teresa

who have made a vocation of service, but there are women everyone knows whose identities the world will never publicly recognize who serve with patience, grace, and love. All of us can learn from the example of these caring women.

Earlier I was describing my impatience with my mother. Looking at her life, I was awed by her service to others. She taught me and all her children about the value and meaning of service. As a child I witnessed her patient care of the sick and dying. Without complaint she gave shelter and aid to them. From her actions I learned the value of giving freely. Remembering these actions is important. It is so easy for all of us to forget the service women give to others in everyday life—the sacrifices women make. Often, sexist thinking obscures the fact that these women make a choice to serve, that they give from the space of free will and not because of biological destiny. There are plenty of folks who are not interested in serving, who disparage service. When anyone thinks a woman who serves "gives 'cause that's what mothers or real women do," they deny her full humanity and thus fail to see the generosity inherent in her acts. There are lots of women who are not interested in service, who even look down on it.

The willingness to sacrifice is a necessary dimension of loving practice and living in community. None of us can have things our way all the time. Giving up something is one way we sustain a commitment to the collective

well-being. Our willingness to make sacrifices reflects our awareness of interdependency. Writing about the need to bridge the gulf between rich and poor, Martin Luther King, Jr., preached: "All men [and women] are caught in an inescapable network of mutuality, tied in a single garment of destiny. Whatever affects one directly affects all indirectly." This gulf is bridged by the sharing of resources. Every day, individuals who are not rich but who are materially privileged make the choice to share with others. Some of us share through conscious tithing (regularly giving a portion of one's income), and others through a daily practice of loving kindness, giving to those in need whom we randomly encounter. Mutual giving strengthens community.

Enjoying the benefits of living and loving in community empowers us to meet strangers without fear and extend to them the gift of openness and recognition. Just by speaking to a stranger, acknowledging their presence on the planet, we make a connection. Every day we all have an opportunity to practice the lessons learned in community. Being kind and courteous connects us to one another. In Peck's book *The Different Drum*, he reminds us that the goal of genuine community is "to seek ways in which to live with ourselves and others in love and peace." Unlike other movements for social change that require joining organizations and attending meetings, we can begin the process of making community wherever we are.

We can begin by sharing a smile, a warm greeting, a bit of conversation; by doing a kind deed or by acknowledging kindness offered us. Daily we can work to bring our families into greater community with one another. My brother was pleased when I suggested he think about moving to the same city where I live so that we could see each other more. It enhanced his feeling of belonging. And it made me feel loved that he wanted to be where I was. Whenever I hear friends talk about estrangement from family members, I encourage them to seek a path of healing, to seek the restoration of bonds. At one point my sister, who is a lesbian, felt that she wanted to break away from the family because family members were often homophobic. Affirming and sharing her rage and disappointment, I also encouraged her to find ways to stay connected. Over time she has seen major positive changes; she has seen fear give way to understanding, which would not have happened had she accepted estrangement as the only response to the pain of rejection.

Whenever we heal family wounds, we strengthen community. Doing this, we engage in loving practice. That love lays the foundation for the constructive building of community with strangers. The love we make in community stays with us wherever we go. With this knowledge as our guide, we make any place we go a place where we return to love.

Nine

MUTUALITY:
THE HEART OF LOVE

True giving is a thoroughly joyous thing to do. We experience happiness when we form the intention to give, in the actual act of giving, and in the recollection of the fact that we have given. Generosity is a celebration. When we give something to someone we feel connected to them, and our commitment to the path of peace and awareness deepens.

— SHARON SALZBERG

LOVE ALLOWS US to enter paradise. Still, many of us wait outside the gates, unable to cross the threshhold, unable to leave behind all the stuff we have accumulated that gets in the way of love. If we have not been guided on love's path for most of our lives, we usually do not know how to begin loving, or what we should do and how we should act. Much of the despair young people feel about love comes from their belief that they are doing everything "right" or that they have done everything right and love is still not happening. Their efforts to love and be loved just produce stress, strife, and perpetual discontent.

In my twenties and early thirties I was confident I knew what love was all about. Yet every time I "fell in love" I found myself in pain. The two most intense partnerships of my life were both with men who are adult children of alcoholic fathers. Neither has memories of interacting

positively with his father. Both were raised by divorced working mothers who never married again. They were similar in temperament to my dad: quiet, hardworking, and emotionally withholding. I can remember when I took the first man home. My sisters were shocked that he was, in their eyes, "so much like Daddy" and "you've always hated Daddy." At the time I thought this was ridiculous, both the notion I hated Dad and the idea that my chosen life partner was in anyway like him—no way.

After fifteen years with this partner, I realized not only how much he was like Dad, I also came face to face with my desperate longing to get the love from him I had not gotten from my father. I wanted him to become both the loving dad and a loving partner, thereby offering me a space of healing. In my fantasy, if he would just love me, give me all the care I had not gotten as a child, it would mend my broken spirit and I would be able to trust and love again. He was unable to do this. He had never been schooled in the way of love. Groping in the shadows of love as much as I was, together we made serious mistakes. He wanted from me the unconditional love and service his mother had always given him without expecting anything in return. Constantly frustrated by his indifference to the needs of others and his smug conviction that this was the way life should be, I tried to do the emotional work for both of us.

Needless to say, I did not get the love I longed for. I

did get to remain in a familiar familial place of struggle. We were engaged in a private gender war. In this battle I fought to destroy the Mars and Venus model so we could break from preconceived ideas about gender roles and be true to our inner longings. He remained wedded to a paradigm of sexual difference that had at its root the assumption that men are inherently different from women, with different emotional needs and longings. In his mind, my problem was my refusal to accept these "natural" roles. Like many liberal men in the age of feminism, he believed women should have equal access to jobs and be given equal pay, but when it came to matters of home and heart he still believed caregiving was the female role. Like many men, he wanted a woman to be "just like his mama" so that he did not have to do the work of growing up.

He was the type of man described by psychologist Dan Kiley in his groundbreaking work *The Peter Pan Syndrome: Men Who Have Never Grown Up*. Published in the early eighties, the jacket noted that this book was about a serious social-psychological phenomenon besetting American males—their refusal to become men: "Though they have reached adult age, they are unable to face adult feelings with responsibilities. Out of touch with their true emotions, afraid to depend on even those closest to them, self-centered and narcissistic, they hide behind masks of normalcy while feeling empty and lonely inside."

This new generation of American men had experienced the feminist cultural revolution. Many of them had been raised in homes where fathers were not present. They were more than happy when feminist thinkers told them that they did not need to be macho men. But the only alternative to not turning into a conventional macho man was to not become a man at all, to remain a boy.

By choosing to remain boys they did not have to undergo the pain of severing the too-tight bonds with mothers who had smothered them with unconditional care. They could just find women to care for them in the same way that their moms had. When women failed to be like Mom, they acted out. Initially, as a young militant feminist, I was thrilled to find a man who was not into being the patriarch. And even the task of dragging him kicking and screaming into adulthood seemed worthwhile. In the end I believed I would have an equal partner, love between peers. But the price I paid for wanting him to become an adult was that he traded in his boyish playfulness and became the macho man I had never wanted to be with. I was the target of his aggression, blamed for cajoling him into leaving boyhood behind, and blamed for his fears that he was not up to the task of being a man. By the time our relationship ended, I had blossomed into a fully self-actualized feminist woman but I had almost lost my faith in the transformative power of love. My heart was broken. I left the relationship fearful that our culture was not yet

ready to affirm mutual love between free women and free men.

IN MY SECOND partnership, with a much younger man, similar power struggles surfaced as he grappled with coming into full adulthood in a society where manhood is always equated with dominance. He was not dominating. But he had to confront a world that saw our relationship solely in terms of power, of who was in charge. Whereas some people had often seen my older partner's silence as intimidating and threatening—a sign of his "power"— my younger partner's silence was usually interpreted as a consequence of my dominance. Initially, I was attracted to this younger partner because his "masculinity" represented an alternative to the patriarchal norm. Ultimately, however, he did not feel that masculinity affirmed in the larger world and began to rely more on conventional thinking about masculine and feminine roles, allowing sexist socialization to shape his actions. Observing his struggle I saw how little support men received when they chose to be disloyal to patriarchy. Although these two liberal men were more than two generations apart, neither had given the question of love much thought. Despite their support of gender equality in the public sphere, privately, deep down, they still saw love as a woman's issue. To them, a relationship was about finding someone to take care of all their needs.

In the Mars-and-Venus-gendered universe, men want power and women want emotional attachment and connection. On this planet nobody really has the opportunity to know love since it is power and not love that is the order of the day. The privilege of power is at the heart of patriarchal thinking. Girls and boys, women and men who have been taught to think this way almost always believe love is not important, or if it is, it is never as important as being powerful, dominant, in control, on top—being right. Women who give seemingly selfless adoration and care to the men in their lives appear to be obsessed with "love," but in actuality their actions are often a covert way to hold power. Like their male counterparts, they enter relationships speaking the words of love even as their actions indicate that maintaining power and control is their primary agenda. This does not mean that care and affection are not present; they are. This is precisely why it is so difficult for women, and some men, to leave relationships where the central dynamic is a struggle for power. The fact that this sadomasochistic power dynamic can and usually does coexist with affection, care, tenderness, and loyalty makes it easy for power-driven individuals to deny their agendas, even to themselves. Their positive actions give hope that love will prevail.

Sadly, love will not prevail in any situation where one party, either female or male, wants to maintain control. My relationships were bittersweet. All the ingredients for

love were present but my partners were not committed to making love the order of the day. When someone has not known love it is difficult for him to trust that mutual satisfaction and growth can be the primary foundation in a coupling relationship. He may only understand and believe in the dynamics of power, of one-up and one-down, of a sadomasochistic struggle for domination, and, ironically, he may feel "safer" when he is operating within these paradigms. Intimate with betrayal, he may have a phobic fear of trust. At least when you hold to the dynamics of power you never have to fear the unknown; you know the rules of the power game. Whatever happens, the outcome can be predicted. The practice of love offers no place of safety. We risk loss, hurt, pain. We risk being acted upon by forces outside our control.

When individuals are wounded in the space where they would know love during childhood, that wounding may be so traumatic that any attempt to reinhabit that space feels utterly unsafe and, at times, seemingly life-threatening. This is especially the case for males. Females, no matter our childhood traumas, are given cultural support for cultivating an interest in love. While sexist logic underlies this support, it still means that females are much more likely to receive encouragement both to think about love and to value its meaning. Our overt longing for love can be expressed and affirmed. This does not, however, mean that women are more able to love than men.

Females are encouraged by patriarchal thinking to believe we should be loving, but this does not mean we are any more emotionally equipped to do the work of love than our male counterparts. Afraid of love, many of us focus more on finding a partner. The widespread success of books like *The Rules: Time-tested Secrets for Capturing the Heart of Mr. Right,* which encourage women to deceive and manipulate to get a partner, express the cynicism of our times. These books validate the old-fashioned sexist notions of sexual difference and encourage women to believe that no relationship between a man and a woman can be based on mutual respect, openness, and caring. The message they give women is that relationships are always and only about power, manipulation, and coercion, about getting someone else to do what you want them to, even if it is against their will. They teach females how to use feminine wiles to play the game of power but they do not offer guidelines for how to love and be loved.

Much popular self-help literature normalizes sexism. Rather than linking habits of being, usually considered innate, to learned behavior that helps maintain and support male domination, they act as though these differences are not value laden or political but are rather inherent and mystical. In these books male inability and/or refusal to honestly express feelings is often talked about as a positive masculine virtue women should learn to accept rather than a learned habit of behavior that creates emotional isola-

tion and alienation. John Gray refers to this as "men entering their cave," and posits it as a given that a woman who disturbs her man when he wants isolation will be punished. Gray believes that it is female behavior that needs to change. Self-help books that are anti–gender equality often present women's overinvestment in nurturance as a "natural," inherent quality rather than a learned approach to caregiving. Much fancy footwork takes place to make it seem that New Age mystical evocations of yin and yang, masculine and feminine androgyny, and so on, are not just the same old sexist stereotypes wrapped in more alluring and seductive packaging.

To know love we must surrender our attachment to sexist thinking in whatever form it takes in our lives. That attachment will always return us to gender conflict, a way of thinking about sex roles that diminishes females *and* males. To practice the art of loving we have first to choose love—admit to ourselves that we want to know love and be loving even if we do not know what that means. The deeply cynical, who have lost all belief in love's power, have to step blindly out on faith. In *The Path to Love,* Deepak Chopra urges us to remember that everything love is meant to do is possible: "The aching need created by lack of love can only be filled by learning anew to love and be loved. We all must discover for ourselves that love is a force as real as gravity, and that being upheld in love every day, every hour, every minute is not a fantasy—

it is intended as our natural state." Most males are not told that they need to be upheld by love every day. Sexist thinking usually prevents them from acknowledging their longing for love or their acceptance of a female as their guide on love's path.

More often than not females are taught in childhood, either by parental caregivers or the mass media, how to give the basic care that is part of the practice of love. We are shown how to be empathic, how to nurture, and, most important, how to listen. Usually we are not socialized in these practices so that we can be loving or share knowledge of love with men, but rather so that we can be maternal in relation to children. Indeed, most adult females readily abandon their basic understanding of the ways one shows care and respect (important ingredients of love) to resocialize themselves so that they can unite with patriarchal partners (male or female) who know nothing about love or the basic rudiments of caregiving. A woman who would never submit to a child calling her abusive names and humiliating her allows such behavior from a man. The respect woman demand and uphold in the maternal-child bond is deemed not important in adult bondings if demanding respect from a man interferes with their desire to get and keep a partner.

Few parental caregivers teach their children to lie. Yet continual lying, either through overt deception or withholding, is often deemed acceptable and excusable adult

male behavior. Choosing to be honest is the first step in the process of love. There is no practitioner of love who deceives. Once the choice has been made to be honest, then the next step on love's path is communication. Writing about the importance of listening in *The Healing of America,* Marianne Williamson calls attention to philosopher Paul Tillich's insistence that the first responsibility of love is to listen: "We cannot learn to communicate deeply until we learn to listen, to each other but also to ourselves and to God. Devotional silence is a powerful tool, for the healing of a heart or the healing of a nation. . . . From there we move up to the next rung on the ladder of healing: our capacity to so communicate our authentic truth as to heal and be healed by its power." Listening does not simply mean we hear other voices when they speak but that we also learn to listen to the voice of our own hearts as well as inner voices.

Getting in touch with the lovelessness within and letting that lovelessness speak its pain is one way to begin again on love's journey. In relationships, whether heterosexual or homosexual, the partner who is hurting often finds that their mate is unwilling to "hear" the pain. Women often tell me that they feel emotionally beaten down when their partners refuse to listen or talk. When women communicate from a place of pain, it is often characterized as "nagging." Sometimes women hear repeatedly that their partners are "sick of listening to this shit." Both cases

undermine self-esteem. Those of us who were wounded in childhood often were shamed and humiliated when we expressed hurt. It is emotionally devastating when the partners we have chosen will not listen. Usually, partners who are unable to respond compassionately when hearing us speak our pain, whether they understand it or not, are unable to listen because that expressed hurt triggers their own feelings of powerlessness and helplessness. Many men never want to feel helpless or vulnerable. They will, at times, choose to silence a partner with violence rather than witness emotional vulnerability. When a couple can identify this dynamic, they can work on the issue of caring, listening to each other's pain by engaging in short conversations at appropriate times (i.e., it's useless to try and speak your pain to someone who is bone weary, irritable, preoccupied, etc.). Setting a time when both individuals come together to engage in compassionate listening enhances communication and connection. When we are committed to doing the work of love we listen even when it hurts.

M. Scott Peck's popular treatise *The Road Less Traveled* highlighted and affirmed the importance of commitment. Discipline and devotion are necessary to the practice of love, all the more so when relationships are just beginning. Peck writes: "Whether it be shallow or not, commitment is the foundation, the bedrock of any genuinely loving relationship. Deep commitment does not guarantee

the success of the relationship but does help more than any other factor to ensure it. . . . Anyone who is truly concerned for the spiritual growth of another knows, consciously or instinctively, that he or she can significantly foster that growth only through a relationship of constancy." Living in a culture where we are encouraged to seek a quick release from any pain or discomfort has fostered a nation of individuals who are easily devastated by emotional pain, however relative. When we face pain in relationships, our first response is often to sever bonds rather than to maintain commitment.

When conflict arises within us or between us and other individuals when we walk on love's path, it is disheartening, especially when we cannot easily right our difficulties. In the case of romantic relationships, many people fear getting trapped in a bond that is not working, so they flee at the onset of conflict. Or they self-indulgently create unnecessary conflict as a way to avoid commitment. They flee from love before they feel its grace. Pain may be the threshold they must cross to partake of love's bliss. Running from the pain, they never know the fullness of love's pleasure.

False notions of love teach us that it is the place where we will feel no pain, where we will be in a state of constant bliss. We have to expose the falseness of these beliefs to see and accept the reality that suffering and pain do not end when we begin to love. In some cases when we are making the slow journey back from lovelessness to

love, our suffering may become more intense. As the lyrics of old-time spirituals testify, "Weeping may endure for a night but joy will come in the morning." Acceptance of pain is part of loving practice. It enables us to distinguish constructive suffering from self-indulgent hurt. When love's promise has never been fulfilled in our lives it is perhaps the most difficult practice of love to trust that the passage through the painful abyss leads to paradise. Guy Corneau suggests in *Lessons in Love* that many men are so fearful of feeling the emotional pain that has been locked away inside them for so long that they willingly choose a life of lovelessness: "A good number of men simply decide not to commit themselves because they cannot face dealing with the emotional pain of love and the conflict it engenders." Women are often belittled for trying to resurrect these men and bring them back to life and to love. They are, in fact, the real sleeping beauties. We might be living in a world that would be even more alienated and violent if caring women did not do the work of teaching men who have lost touch with themselves how to live again. This labor of love is futile only when the men in question refuse to awaken, refuse growth. At this point it is a gesture of self-love for women to break their commitment and move on.

Women have endeavored to guide men to love because patriarchal thinking has sanctioned this work even as it has undermined it by teaching men to refuse guidance. It

sets up a gendered arrangement in which men are more likely to get their emotional needs met while women will be deprived. Getting your emotional needs met helps create greater psychological well-being. As a consequence, men are given an advantage that neatly coincides with the patriarchal insistence that they are superior and therefore better suited to rule others. Were women's emotional needs met, were mutuality the norm, male domination might lose its allure. Sadly, the men's movement that emerged in response to the feminist critique of sexist masculinity often encouraged men to get in touch with their feeling but to share them only in a "safe" context, usually only with other men. Robert Bly, a major leader of this movement, had little to say about men and love. Men in the movement did not urge one another to look to enlightened women for guidance in the way of love.

Those who choose to walk on love's path are well served if they have a guide. That guide can enable us to overcome fear if we trust that they will not lead us astray or abandon us along the way. I am always amazed by how much courageous trust we offer strangers. We get sick and enter hospitals where we put our trust in a collective body of people we don't know, who we hope will make us well. Yet we often fear placing our emotional trust in caring individuals who may have been faithful friends all our lives. This is simply misguided thinking. And it must be overcome if we are to be transformed by love.

The practice of love takes time. Without a doubt, the way we work in this society leaves individuals with little time when they are not physically and emotionally tired to work on the art of loving. How many times do we hear anyone say that they were working so hard and had no time for love, so they had to cut back or even leave a job to make a space to be loving? While movies like *Regarding Henry* and *The Fisher King* spin sentimental narratives about ruling-class men suffering life-threatening illnesses that lead them to reevaluate how they spend their time, in real life we have yet to see abundant examples of powerful men or women pausing to create a place to do the work of love in their lives. Certainly, individuals who love someone who is more preoccupied by work feel immense frustration when they endeavor to guide their partner in the way of love. Truly, there would no unemployment problem in our nation if our taxes subsidized schools where everyone could learn to love. Job sharing could become the norm. With love at the center of our lives, work could have a different meaning and focus.

When we practice love, we want to give more. Selfishness, a refusal to give acceptance to another, is a central reason romantic relationships fail. In *Love the Way You Want It,* Robert Sternberg confirms: "If I were asked the single most frequent cause of the destruction of relationships . . . I would say it is selfishness. We live in an age of narcissism and many people have never learned or have

forgotten how to listen to the needs of others. The truth is, if you want to make just one change in yourself that will improve your relationship—literally, overnight—it would be to put your partner's interest on an equal footing with your own." Giving generously in romantic relationships, and in all other bonds, means recognizing when the other person needs our attention. Attention is an important resource.

Generous sharing of all resources is one concrete way to express love. These resources can be time, attention, material objects, skills, money etc . . . Once we embark on love's path we see how easy it is to give. A useful gift all love's practitioners can give is the offering of forgiveness. It not only allows us to move away from blame, from seeing others as the cause of our sustained lovelessness, but it enables us to experience agency, to know we can be responsible for giving and finding love. We need not blame others for feelings of lack, for we know how to attend to them. We know how to give ourselves love and to recognize the love that is all around us. Much of the anger and rage we feel about emotional lack is released when we forgive ourselves and others. Forgiveness opens us up and prepares us to receive love. It prepares the way for us to give wholeheartedly.

Giving brings us into communion with everyone. It is one way for us to understand that there is truly enough of everything for everybody. In the Christian tradition we

are told that giving "opens the windows of heaven" so that we can be offered "a blessing that there will not be room enough to receive." In patriarchal society men who want to break with domination can best begin the practice of love by being giving, by being generous. This is why feminist thinkers extolled the virtues of male parenting. Working as caregivers to young children, many men are able to experience for the first time the joy that comes from service.

Through giving to each other we learn how to experience mutuality. To heal the gender war rooted in struggles for power, women and men choose to make mutuality the basis of their bond, ensuring that each person's growth matters and is nurtured. It enhances our power to know joy. In *A Heart As Wide As the World,* Sharon Salzberg reminds us: "The practice of generosity frees us from the sense of isolation that arises from clinging and attachment." Cultivating a generous heart, which is, as Salzberg writes, "the primary quality of an awakened mind," strengthens romantic bonds. Giving is the way we also learn how to receive. The mutual practice of giving and receiving is an everyday ritual when we know true love. A generous heart is always open, always ready to receive our going and coming. In the midst of such love we need never fear abandonment. This is the most precious gift true love offers—the experience of knowing we always belong.

Giving is healing to the spirit. We are admonished by spiritual tradition to give gifts to those who would know love. Love is an action, a participatory emotion. Whether we are engaged in a process of self-love or of loving others we must move beyond the realm of feeling to actualize love. This is why it is useful to see love as a practice. When we act, we need not feel inadequate or powerless; we can trust that there are concrete steps to take on love's path. We learn to communicate, to be still and listen to the needs of our hearts, and we learn to listen to others. We learn compassion by being willing to hear the pain, as well as the joy, of those we love. The path to love is not arduous or hidden, but we must choose to take the first step. If we do not know the way, there is always a loving spirit with an enlightened, open mind able to show us how to take the path that leads to the heart of love, the path that lets us return to love.

Ten

ROMANCE:
SWEET LOVE

Sweet Love say

Where, how and when

What do you want of me?...

Yours I am, for You I was born:

What do you want of me?...

—Saint Teresa of Avila

To return to love, to get the love we always wanted but never had, to have the love we want but are not prepared to give, we seek romantic relationships. We believe these relationships, more than any other, will rescue and redeem us. True love does have the power to redeem but only if we are ready for redemption. Love saves us only if we want to be saved. So many seekers after love are taught in childhood to feel unworthy, that nobody could love them as they really are, and they construct a false self. In adult life they meet people who fall in love with their false self. But this love does not last. At some point, glimpses of the real self emerge and disappointment comes. Rejected by their chosen love, the message received in childhood is confirmed: Nobody could love them as they really are.

Few of us enter romantic relationships able to receive love. We fall into romantic attachments doomed to replay

familiar family dramas. Usually we do not know this will happen precisely because we have grown up in a culture that has told us that no matter what we experienced in our childhoods, no matter the pain, sorrow, alienation, emptiness, no matter the extent of our dehumanization, romantic love will be ours. We believe we will meet the girl of our dreams. We believe "someday our prince will come." They show up just as we imagined they would. We wanted the lover to appear but most of us were not really clear about what we wanted to do with them—what the love was that we wanted to make and how we would make it. We were not ready to open our hearts fully.

In her first book, *The Bluest Eye,* novelist Toni Morrison identifies the idea of romantic love as one "of the most destructive ideas in the history of human thought." Its destructiveness resides in the notion that we come to love with no will and no capacity to choose. This illusion, perpetuated by so much romantic lore, stands in the way of our learning how to love. To sustain our fantasy we substitute romance for love.

When romance is depicted as a project, or so the mass media, especially movies, would have us believe, women are the architects and the planners. Everyone likes to imagine that women are romantics, sentimental about love, that men follow where women lead. Even in non-heterosexual relationships, the paradigms of leader and follower often prevail, with one person assuming the role

deemed feminine and another the designated masculine role. No doubt it was someone playing the role of leader who conjured up the notion that we "fall in love," that we lack choice and decision when choosing a partner because when the chemistry is present, when the click is there, it just happens—it overwhelms—it takes control. This way of thinking about love seems to be especially useful for men who are socialized via patriarchal notions of masculinity to be out of touch with what they feel. In the essay "Love and Need," Thomas Merton contends: "The expression to 'fall in love' reflects a peculiar attitude toward love and life itself—a mixture of fear, awe, fascination, and confusion. It implies suspicion, doubt, hesitation in the presence of something unavoidable, yet not fully reliable." If you do not know what you feel, then it is difficult to choose love; it is better to fall. Then you do not have to be responsible for your actions.

Even though psychoanalysts, from Fromm writing in the fifties to Peck in the present day, critique the idea that we fall in love, we continue to invest in the fantasy of effortless union. We continue to believe we are swept away, caught up in the rapture, that we lack choice and will. In *The Art of Loving,* Fromm repeatedly talks about love as action, "essentially an act of will." He writes: "To love somebody is not just a strong feeling—it is a decision, it is a judgment, it is a promise. If love were only a feeling, there would be no basis for the promise to love each other

forever. A feeling comes and it may go." Peck builds upon Fromm's definition when he describes love as the will to nurture one's own or another's spiritual growth, adding: "The desire to love is not itself love. Love is as love does. Love is an act of will—namely, both an intention and action. Will also implies choice. We do not have to love. We choose to love." Despite these brilliant insights and the wise counsel they offer, most people remain reluctant to embrace the idea that it is more genuine, more real, to think of choosing to love rather than falling in love.

Describing our romantic longings in *Life Preservers,* therapist Harriet Lerner shares that most people want a partner "who is mature and intelligent, loyal and trustworthy, loving and attentive, sensitive and open, kind and nurturant, competent and responsible." No matter the intensity of this desire, she concludes: "Few of us evaluate a prospective partner with the same objectivity and clarity that we might use to select a household appliance or a car." To be capable of critically evaluating a partner we would need to be able to stand back and look critically at ourselves, at our needs, desires, and longings. It was difficult for me to really take out a piece of paper and evaluate myself to see if I was able to give the love I wanted to receive. And even more difficult to make a list of the qualities I wanted to find in a mate. I listed ten items. And then when I applied the list to men I had chosen as potential partners,

it was painful to face the discrepancy between what I wanted and what I had chosen to accept. We fear that evaluating our needs and then carefully choosing partners will reveal that there is no one for us to love. Most of us prefer to have a partner who is lacking than no partner at all. What becomes apparent is that we may be more interested in finding a partner than in knowing love.

Time and time again when I talk to individuals about approaching love with will and intentionality, I hear the fear expressed that this will bring an end to romance. This is simply not so. Approaching romantic love from a foundation of care, knowledge, and respect actually intensifies romance. By taking the time to communicate with a potential mate we are no longer trapped by the fear and anxiety underlying romantic interactions that take place without discussion or the sharing of intent and desire. I talked with a woman friend who stated that she had always been extremely fearful of sexual encounters, even when she knew someone well and desired them. Her fear was rooted in a shame she felt about the body, sentiments she had learned in childhood. Previously, her encounters with men had only intensified that shame. Usually men made light of her anxiety. I suggested she might try meeting with the new man in her life over lunch with the set agenda of talking to him about sexual pleasure, their likes and dislikes, their hopes and fears. She reported back that

the lunch was incredibly erotic; it laid the groundwork for them to be at ease with each other sexually when they finally reached that stage in their relationship.

EROTIC ATTRACTION OFTEN serves as the catalyst for an intimate connection between two people, but it is not a sign of love. Exciting, pleasurable sex can take place between two people who do not even know each other. Yet the vast majority of males in our society are convinced that their erotic longing indicates who they should, and can, love. Led by their penis, seduced by erotic desire, they often end up in relationships with partners with whom they share no common interests or values. The pressure on men in a patriarchal society to "perform" sexually is so great that men are often so gratified to be with someone with whom they find sexual pleasure that they ignore everything else. They cover up these mistakes by working too much, or finding playmates they like outside their committed marriage or partnership. It usually takes them a long time to name the lovelessness they may feel. And this recognition usually has to be covered up to protect the sexist insistence that men never admit failure.

Women rarely choose men solely on the basis of erotic connection. While most females acknowledge the importance of sexual pleasure, they recognize that it is not the only ingredient needed to build strong relationships. And let's face it, the sexism of stereotyping women as caregiv-

ers makes it acceptable for women to articulate emotional needs. So females are socialized to be more concerned about emotional connection. Women who have only named their erotic hunger in the wake of the permission given by the feminist movement and sexual liberation have always been able to speak their hunger for love. This does not mean that we find the love we long for. Like males, we often settle for lovelessness because we are attracted to other aspects of a partner's makeup. Shared sexual passion can be a sustaining and binding force in a troubled relationship, but it is not the proving ground for love.

This is one of the great sadnesses of life. Too often women, and some men, have their most intense erotic pleasure with partners who wound them in other ways. The intensity of sexual intimacy does not serve as a catalyst for respect, care, trust, understanding, and commitment. Couples who rarely or never have sex can know lifelong love. Sexual pleasure enhances the bonds of love, but they can exist and satisfy when sexual desire is absent. Ultimately, most of us would choose great love over sustained sexual passion if we had to. Luckily we do not have to make this choice because we usually have satisfying erotic pleasure with our loved one.

The best sex and the most satisfying sex are not the same. I have had great sex with men who were intimate terrorists, men who seduce and attract by giving you just what you feel your heart needs then gradually or abruptly

withholding it once they have gained your trust. And I have been deeply sexually fulfilled in bonds with loving partners who have had less skill and know-how. Because of sexist socialization, women tend to put sexual satisfaction in its appropriate perspective. We acknowledge its value without allowing it to become the absolute measure of intimate connection. Enlightened women want fulfilling erotic encounters as much as men, but we ultimately prefer erotic satisfaction within a context where there is loving, intimate connection. If men were socialized to desire love as much as they are taught to desire sex, we would see a cultural revolution. As it stands, most men tend to be more concerned about sexual performance and sexual satisfaction than whether they are capable of giving and receiving love.

Even though sex matters, most of us are no more able to articulate sexual needs and longings than we are able to speak our desire for love. Ironically, the presence of life-threatening sexually transmitted diseases has become the reason more couples communicate with each other about erotic behavior. The very people (many of them men) who had heretofore claimed that "too much talk" made things less romantic find that talk does not threaten pleasure at all. It merely changes its nature. Where once knowing nothing was the basis for excitement and erotic intensity, knowing more is now the basis. Lots of people who feared a loss of romantic and/or erotic intensity made

this radical change in their thinking and were surprised to find that their previous assumptions that talk killed romance were wrong.

Cultural acceptance of this change shows that we are all capable of shifting our paradigms, the foundational ways of thinking and doing things that become habitual. We are all capable of changing our attitudes about "falling in love." We can acknowledge the "click" we feel when we meet someone new as just that—a mysterious sense of connection that may or may not have anything to do with love. However it could or could not be the primal connection while simultaneously acknowledging that it will lead us to love. How different things might be if, rather than saying "I think I'm in love," we were saying "I've connected with someone in a way that makes me think I'm on the way to knowing love." Or if instead of saying "I am in love" we said "I am loving" or "I will love." Our patterns around romantic love are unlikely to change if we do not change our language.

We are all uncomfortable with the conventional expressions we use to talk about romantic love. All of us feel that these expressions and the thinking behind them are one of the reasons we entered relationships that did not work. In retrospect we see that to a grave extent the way we talked about these bonds foreshadowed what happened in the relationship. I certainly changed the way I talk and think about love in response to the emotional

lack I felt within myself and in my relationships. Starting with clear definitions of love, of feeling, intention, and will, I no longer enter relationships with the lack of awareness that leads me to make all bonds the site for repeating old patterns.

Although I have experienced many disappointments in my quest to love and be loved, I still believe in the transformative power of love. Disappointment has not led me to close my heart. However, the more I talk with people around me I find disappointment to be widespread and it does lead many folks to feel profoundly cynical about love. A lot of people simply think we make too much of love. Our culture may make much of love as compelling fantasy or myth, but it does not make much of the art of loving. Our disappointment about love is directed at romantic love. We fail at romantic love when we have not learned the art of loving. It's as simple as that. Often we confuse perfect passion with perfect love. A perfect passion happens when we meet someone who appears to have everything we have wanted to find in a partner. I say "appears" because the intensity of our connection usually blinds us. We see what we want to see. In *Soul Mates,* Thomas Moore contends that the enchantment of romantic illusion has its place and that "the soul thrives on ephemeral fantasies." While perfect passion provides us with its own particular pleasure and danger, for those of us seeking perfect love it can only ever be a preliminary stage in the process.

We can only move from perfect passion to perfect love when the illusions pass and we are able to use the energy and intensity generated by intense, overwhelming, erotic bonding to heighten self-discovery. Perfect passions usually end when we awaken from our enchantment and find only that we have been carried away from ourselves. It becomes perfect love when our passion gives us the courage to face reality, to embrace our true selves. Acknowledging this meaningful link between perfect passion and perfect love from the onset of a relationship can be the necessary inspiration that empowers us to choose love. When we love by intention and will, by showing care, respect, knowledge, and responsibility, our love satisfies. Individuals who want to believe that there is no fulfillment in love, that true love does not exist, cling to these assumptions because this despair is actually easier to face than the reality that love is a real fact of life but is absent from their lives.

In the last two years I have talked a lot about love. My topic has been "true love." It all started when I began to speak my heart's desire, to say to friends, lecture audiences, folks sitting next to me on buses and planes and in restaurants that "I was looking for true love." Cynically, almost all my listeners would let me know that I was looking for a myth. The few who still believe in true love offered their deep conviction that "you can't look for it," that if it's meant for you "it will just happen." Not only

do I believe wholeheartedly that true love exists, I embrace the idea that its occurence is a mystery—that it happens without any effort of human will. And if that's the case, then it will happen whether we look for it or not. But we do not lose love by looking for it. Indeed, those among us who have been hurt, disappointed, disillusioned must open our hearts if we want love to enter. That act of opening is a way of seeking love.

I have had a taste of true love. That experience intensifies my longing and my desire to search. A true love in my life first appeared to me in a dream. I had been invited to a conference on film and was reluctant to attend. I hate being bombarded by lots of new ideas at one time; it feels to me like overeating. Yet I had a dream in which I was told that if I went to this conference I would meet a man of my dreams. Images in the dream were so vivid and real that I awakened with a sense of necessity. I called a girlfriend and told her my story. She agreed to go to the conference with me, as my witness. A few weeks later we arrived at the conference in the middle of a session in which speakers were onstage. I pointed to the man whose image had appeared in my dream. After the session I met him and we talked. Meeting him was like seeing a long-lost relative or friend. We went to dinner. There was a feeling of mutual recognition between us from the start. It was as though we knew each other. As our conversation progressed he told me he was in a committed relationship.

I was puzzled and disturbed. I could not believe divine forces in the universe would lead me to this man of my dreams when there was no real possibility of fully realizing those dreams. Of course, those dreams were all about being in a romantic relationship. That was the beginning of a difficult lesson in true love.

I LEARNED THAT we may meet a true love and that our lives may be transformed by such an encounter even when it does not lead to sexual pleasure, committed bonding, or even sustained contact. The myth of true love—that fairy-tale vision of two souls who meet, join, and live happily thereafter—is the stuff of childhood fantasy. Yet many of us, female and male, carry these fantasies into adulthood and are unable to cope with the reality of what it means either to have an intense life-altering connection that will not lead to an ongoing relationship or to be in a relationship. True love does not always lead to happily ever after, and even when it does, sustaining love still takes work.

All relationships have ups and downs. Romantic fantasy often nurtures the belief that difficulties and down times are an indication of a lack of love rather than part of the process. In actuality, true love thrives on the difficulties. The foundation of such love is the assumption that we want to grow and expand, to become more fully ourselves. There is no change that does not bring with it a feeling of

challenge and loss. When we experience true love it may feel as though our lives are in danger; we may feel threatened.

True love is different from the love that is rooted in basic care, goodwill, and just plain old everyday attraction. We are all continually attracted to folks (we like their style, the way they think, the way they look, etc.) whom we know that, given a chance, we could love in a heartbeat. In his insightful book *Love and Awakening: Discovering the Sacred Path of Intimate Relationship*, John Welwood makes a useful distinction between this type of attraction, familiar to us all, which he calls a "heart connection," and another type he calls a "soul connection." Here is how he defines it: "A soul connection is a resonance between two people who respond to the essential beauty of each other's individual natures, behind their facades, and who connect on a deeper level. This kind of mutual recognition provides the catalyst for a potent alchemy. It is a sacred alliance whose purpose is to help both partners discover and realize their deepest potentials. While a heart connection lets us appreciate those we love just as they are, a soul connection opens up a further dimension—seeing and loving them for who they could be, and for who we could become under their influence." Making a heart connection with someone is usually not a difficult process.

Throughout our lives we meet lots of people with whom

we feel that special click that could take us on the path of love. But this click is not the same as a soul connection. Often, a deeper bonding with another person, a soul connection, happens whether we will it to be so or not. Indeed, sometimes we are drawn toward someone without knowing why, even when we do not desire contact. Several couples I talked with who have found true love enjoyed telling the story of how one of them did not find the other at all appealing at first meeting even though they felt mysteriously joined to that individual. In all cases where individuals felt that they had known true love, everyone testified that the bonding was not easy or simple. To many folks this seems confusing precisely because our fantasy of true love is that it will be just that—simple and easy.

Usually we imagine that true love will be intensely pleasurable and romantic, full of love and light. In truth, true love is all about work. The poet Rainer Maria Rilke wisely observed: "Like so much else, people have also misunderstood the place of love in life, they have made it into play and pleasure because they thought that play and pleasure was more blissful than work; but there is nothing happier than work, and love, just because it is the extreme happiness, can be nothing else but work . . ." The essence of true love is mutual recognition—two individuals seeing each other as they really are. We all know that the usual approach is to meet someone we like and put our best self

forward, or even at times a false self, one we believe will be more appealing to the person we want to attract. When our real self appears in its entirety, when the good behavior becomes too much to maintain or the masks are taken away, disappointment comes. All too often individuals feel, after the fact—when feelings are hurt and hearts are broken—that it was a case of mistaken identity, that the loved one is a stranger. They saw what they wanted to see rather than what was really there.

True love is a different story. When it happens, individuals usually feel in touch with each other's core identity. Embarking on such a relationship is frightening precisely because we feel there is no place to hide. We are known. All the ecstacy that we feel emerges as this love nurtures us and challenges us to grow and transform. Describing true love, Eric Butterworth writes: "True love is a peculiar kind of insight through which we see the wholeness which the person is—at the same time totally accepting the level on which he now expresses himself—without any delusion that the potential is a present reality. True love accepts the person who now is without qualifications, but with a sincere and unwavering commitment to help him to achieve his goals of self-unfoldment—which we may see better than he does." Most of the time, we think that love means just accepting the other person as they are. Who among us has not learned the hard way that we cannot change someone, mold them and make

them into the ideal beloved we might want them to be. Yet when we commit to true love, we are committed to being changed, to being acted upon by the beloved in a way that enables us to be more fully self-actualized. This commitment to change is chosen. It happens by mutual agreement. Again and again in conversations the most common vision of true love I have heard shared was one that declared it to be "unconditional." True love *is* unconditional, but to truly flourish it requires an ongoing commitment to constructive struggle and change.

The heartbeat of true love is the willingness to reflect on one's actions, and to process and communicate this reflection with the loved one. As Welwood puts it: "Two beings who have a soul connection want to engage in a full, free-ranging dialogue and commune with each other as deeply as possible." Honesty and openness is always the foundation of insightful dialogue. Most of us have not been raised in homes where we have seen two deeply loving grown folks talking together. We do not see this on television or at the movies. And how can any of us communicate with men who have been told all their lives that they should not express what they feel. Men who want to love and do not know how must first come to voice, must learn to let their hearts speak—and then to speak truth. Choosing to be fully honest, to reveal ourselves, is risky. The experience of true love gives us the courage to risk.

As long we are afraid to risk we cannot know love.

Hence the truism: "Love is letting go of fear." Our hearts connect with lots of folks in a lifetime but most of us will go to our graves with no experience of true love. This is in no way tragic, as most of us run the other way when true love comes near. Since true love sheds light on those aspects of ourselves we may wish to deny or hide, enabling us to see ourselves clearly and without shame, it is not surprising that so many individuals who say they want to know love turn away when such love beckons.

NO MATTER HOW often we turn our minds and hearts away—or how stubbornly we refuse to believe in its magic—true love exists. Everyone wants it, even those who claim to have given up hope. But not everyone is ready. True love appears only when our hearts are ready. A few years ago I was sick and had one of those cancer scares where the doctor tells you if the tests are positive you will not have long to live. Hearing his words I lay there thinking, I could not possibly die because I am not ready, I have not known true love. Right then I committed myself to opening my heart; I was ready to receive such love. And it came.

This relationship did not last forever, and that was difficult to face. All the romantic lore of our culture has told us when we find true love with a partner it will continue. Yet this partnership lasts only if both parties remain committed to being loving. Not everyone can bear the weight

of true love. Wounded hearts turn away from love because they do not want to do the work of healing necessary to sustain and nurture love. Many men, especially, often turn away from true love and choose relationships in which they can be emotionally withholding when they feel like it but still receive love from someone else. Ultimately, they choose power over love. To know and keep true love we have to be willing to surrender the will to power.

When one knows a true love, the transformative force of that love lasts even when we no longer have the company of the person with whom we experienced profound mutual care and growth. Thomas Merton writes: "We discover our true selves in love." Many of us are not ready to accept and embrace our true selves, particularly when living with integrity alienates us from our familiar worlds. Often, when we undergo a process of self-recovery, for a time we may find ourselves more alone. Writing about choosing solitude over company that does not nurture one's soul, Maya Angelou reminds us that "it is never lonesome in Babylon." Fear of facing true love may actually lead some individuals to remain in situations of lack and unfulfillment. There they are not alone, they are not at risk.

To love fully and deeply puts us at risk. When we love we are changed utterly. Merton asserts: "Love affects more than our thinking and our behavior toward those we love. It transforms our entire life. Genuine love is a

personal revolution. Love takes your ideas, your desires, and your actions and welds them together in one experience and one living reality which is a new you." We often are in flight from the "new you." Richard Bach's autobiographical love story *Illusions* describes both his flight from love and his return. To return to love he had to be willing to sacrifice and surrender, to let go of the fantasy of being someone with no sustained emotional needs to acknowledge his need to love and be loved. We sacrifice our old selves in order to be changed by love and we surrender to the power of the new self.

Love within the context of romantic bonding offers us the unique chance to be transformed in a welcoming celebratory atmosphere. Without "falling in love," we can recognize that moment of mysterious connection between our soul and that of another person as love's attempt to call us back to our true selves. Intensely connecting with another soul, we are made bold and courageous. Using that fearless will to bond and connect as a catalyst for choosing and committing ourselves to love, we are able to love truly and deeply, to give and receive a love that lasts, a love that is "stronger than death."

Eleven

LOSS:

LOVING INTO LIFE AND DEATH

You have to trust that every friendship has no end, that a communion of saints exists among all those, living and dead, who have truly loved God and one another. You know from experience how real this is. Those you have loved deeply and who have died live on in you, not just as memories but as real presences.

—HENRI NOUWEN

LOVE MAKES US feel more alive. Living in a state of lovelessness we feel we might as well be dead; everything within us is silent and still. We are unmoved. "Soul murder" is the term psychoanalysts use to describe this state of living death. It echoes the biblical declaration that "anyone who does not know love is still in death." Cultures of domination court death. Hence the ongoing fascination with violence, the false insistence that it is natural for the strong to prey upon the weak, for the more powerful to prey upon the powerless. In our culture the worship of death is so intense it stands in the way of love. On his deathbed Erich Fromm asked a beloved friend why we prefer love of death to love of life, why "the human race prefers necrophilia to biophilia." Coming from Fromm this question was merely rhetorical, as he had spent his life explaining our cultural failure to fully embrace the reality that love gives life meaning.

Unlike love, death will touch us all at some point in our lives. We will witness the death of others or we will witness our own dying, even if it's just in that brief instance when life is fading away. Living with lovelessness is not a problem we openly and readily complain about. Yet the reality that we will all die generates tremendous concern, fear, and worry. It may very well be that the worship of death, indicated by the constant spectacles of dying we watch on television screens daily, is one way our culture tries to still that fear, to conquer it, to make us comfortable. Writing about the meaning of death in contemporary culture Thomas Merton explains: "Psychoanalysis has taught us something about the death wish that pervades the modern world. We discover our affluent society to be profoundly addicted to the love of death. . . . In such a society, though much may officially be said about human values, whenever there is, in fact, a choice between the living and the dead, between men and money, or men and power, or men and bombs, the choice will always be for death, for death is the end or the goal of life." Our cultural obsession with death consumes energy that could be given to the art of loving.

The worship of death is a central component of patriarchal thinking, whether expressed by women or men. Visionary theologians see the failure of religion as one reason our culture remains death centered. In his work *Original Blessing,* Matthew Fox explains: "Western civi-

lization has preferred love of death to love of life to the very extent that its religious traditions have preferred redemption to creation, sin to ecstasy, and individual introspection to cosmic awareness and appreciation." For the most part, patriarchal perspectives have shaped religious teaching and practice. Recently, there has been a turning away from these teachings toward a creation-grounded spirituality that is life-affirming. Fox calls this "the via positiva": "Without this solid grounding in creation's powers we become bored, violent people. We become necrophiliacs in love with death and the powers and principalities of death." We move away from this worship of death by challenging patriarchy, creating peace, working for justice, and embracing a love ethic.

Ironically, the worship of death as a strategy for coping with our underlying fear of death's power does not truly give us solace. It is deeply anxiety producing. The more we watch spectacles of meaningless death, of random violence and cruelty, the more afraid we become in our daily lives. We cannot embrace the stranger with love for we fear the stranger. We believe the stranger is a messenger of death who wants our life. This irrational fear is an expression of madness if we think of madness as meaning we are out of touch with reality. Even though we are more likely to be hurt by someone we know than a stranger, our fear is directed toward the unknown and the unfamiliar. That fear brings with it intense paranoia and a

constant obsession with safety. The growing number of gated communities in our nation is but one example of the obsession with safety. With guards at the gate, individuals still have bars and elaborate internal security systems. Americans spend more than thirty billion dollars a year on security. When I have stayed with friends in these communities and inquired as to whether all the security is in response to an actual danger I am told "not really," that it is the fear of threat rather than a real threat that is the catalyst for an obsession with safety that borders on madness.

Culturally we bear witness to this madness every day. We can all tell endless stories of how it makes itself known in everyday life. For example, an adult white male answers the door when a young Asian male rings the bell. We live in a culture where without responding to any gesture of aggression or hostility on the part of the stranger, who is simply lost and trying to find the correct address, the white male shoots him, believing he is protecting his life and his property. This is an everyday example of madness. The person who is really the threat here is the home owner who has been so well socialized by the thinking of white supremacy, of capitalism, of patriarchy that he can no longer respond rationally.

White supremacy has taught him that all people of color are threats irrespective of their behavior. Capitalism has taught him that, at all costs, his property can and must be

protected. Patriarchy has taught him that his masculinity has to be proved by the willingness to conquer fear through aggression; that it would be unmanly to ask questions before taking action. Mass media then brings us the news of this in a newspeak manner that sounds almost jocular and celebratory, as though no tragedy has happened, as though the sacrifice of a young life was necessary to uphold property values and white patriarchal honor. Viewers are encouraged feel sympathy for the white male home owner who made a mistake. The fact that this mistake led to the violent death of an innocent young man does not register; the narrative is worded in a manner that encourages viewers to identify with the one who made the mistake by doing what we are led to feel we might all do to "protect our property at all costs from any sense of perceived threat." This is what the worship of death looks like.

All the worship of death we see on our television screens, all the death we witness daily, does not prepare us in any way to face dying with awareness, clarity, or peace of mind. When worship of death is rooted in fear it does not enable us to live fully or well. Merton contends: "If we become obsessed with the idea of death hiding and waiting for us in ambush, we are not making death more real but life less real. Our life is divided against itself. It becomes a tug of war between the love and the fear of itself. Death then operates in the midst of life, not

as the end of life, but rather, as the fear of life." To live fully we would need to let go of our fear of dying. That fear can only be addressed by the love of living. We have a long history in this nation of believing that to be too celebratory is dangerous, that being optimistic is fool-hardy, hence our difficulty in celebrating life, in teaching our children and ourselves how to love life.

Many of us come to love life only when faced with life-threatening illness. Certainly, facing the possibility of my own death gave me the courage to confront the lack of love in my life. Much contemporary visionary work on death and dying has highlighted learning how to love. Loving makes it possible for us to change our worship of death to a celebration of life. In an unsent letter written to a true love in my life I wrote: "During the memorial service for her sister my friend gave testimony in which she declared 'death has left us loving her completely.' We are so much more able to embrace the loss of intimate loved ones and friends when we know that we have given our all—when we have shared with them that mutual rec-ognition and belonging in love which death can never change or take away. Each day I am grateful for having known a love that enables me to embrace death with no fear of incompleteness or lack, with no sense of irredeem-able regret. That is a gift you gave. I cherish it; nothing changes its value. It remains precious." Loving does this.

Love empowers us to live fully and die well. Death becomes, then, not an end to life but a part of living.

In her autobiography, *The Wheel of Life,* published shortly after her death, Elisabeth Kübler-Ross tells the story of her awakening to the realization that we can face death without fear: "In these earliest days of what would become known as the birth of thanatology—or the study of death—my greatest teacher was a black cleaning woman. I do not remember her name . . . but what drew my attention to her was the effect she had on many of the most seriously ill patients. Each time she left their rooms, there was, I noticed, a tangible difference in their attitudes. I wanted to know her secret. Desperately curious, I literally spied on this woman who had never finished high school but knew a big secret." The secret that this wise black woman knew, which Kübler-Ross positively appropriated, was that we must befriend death and let it be our guide in life, meeting it unafraid. When the black cleaning lady who had triumphed over many hardships in her own life, who had lost loved ones to early deaths, entered the rooms of the dying she brought with her a willingness to talk openly about death without fear. This nameless angel gave Kübler-Ross the most valuable lesson of her life, telling her: "Death is not a stranger to me. He is an old, old acquaintance." It takes courage to befriend death. We find that courage in life through loving.

Our collective fear of death is a dis-ease of the heart. Love is the only cure. Many people approach death with despair because they realize they have not lived their lives as they wanted to. They never found their "true selves" or they never found the love their hearts longed to know. Sometimes, facing death they offer themselves the love they did not offer for most of their lives. They give themselves acceptance, the unconditional love that is the core of self-love. In her foreword to *Intimate Death*, Marie De Hennezel describes witnessing the way approaching death can enable people to become more fully self-actualized. She writes: "At the moment of utter solitude, when the body breaks down on the edge of infinity, a separate time begins to run that cannot be measured in any normal way. In the course of several days something happens, with the help of another presence that allows despair and pain to declare themselves, the dying seize hold of their lives, take possession of them, unlock their truth. They discover the freedom of being true to themselves." This deathbed recognition of love's power is a moment of ecstasy. We would be lucky if we felt its power all our days and not just when those days are ending.

When we love every day we do not need the eminent threat of sure death to be true to ourselves. Living with awareness and clarity of mind and heart we are able to embrace the realization of our dying in a manner that al-

lows us to live more fully because we know death is always with us. There is no one among us who is a stranger to death. Our first home in the womb is also a grave where we await the coming of life. Our first experience of living is a moment of resurrection, a movement out of the shadows and into the light. When we watch a child physically coming out of the womb we know we are in the presence of the miraculous.

Yet it does not take long for us to forget the magical harmony of the transition from death into life. And death soon becomes the passage we want to avoid. But it has become harder for our nation to flee death. Even though, on the average, we have longer life spans, death surrounds us now more than ever, as so many life-threatening diseases take the lives of loved ones, friends, and acquaintances, many of whom are young in years. This strong presence of dying often cannot penetrate our cultural denial that death is always among us, and people still refuse to let an awareness of death guide them.

When I was a little girl, our mother talked with ease about the possibility of death. Often, when we would put off for tomorrow the things that could be done today, she would remind us that "life is not promised." This was her way of urging us to live life to the fullest—to live so that we would be without regret. I am continually surprised when friends, and strangers, act as though any talk of

death is a sign of pessimism or morbidity. Death is among us. To see it always and only as a negative subject is to lose sight of its power to enhance every moment.

Luckily, those healers and comforters who work with the dying show us how to face the reality of death, so that talking about it is not taboo. Just as we are often unable to speak about our need to love and be loved because we fear our words would be interpreted as signs of weakness or failure, so are we rarely able to share our thoughts about death and dying. No wonder then that we are collectively unable to confront the significance of grief. Just as the dying are often carted off so that the process of dying will be witnessed by only a select few, grieving individuals are encouraged to let themselves go only in private, in appropriate settings away from the rest of us. Sustained grief is particularly disturbing in a culture that offers a quick fix for any pain. Sometimes it amazes me to know intuitively that the grieving are all around us yet we do not see any overt signs of their anguished spirits. We are taught to feel shame about grief that lingers. Like a stain on our clothes, it marks us as flawed, imperfect. To cling to grief, to desire its expression, is to be out of sync with modern life, where the hip do not get bogged down in mourning.

Love knows no shame. To be loving is to be open to grief, to be touched by sorrow, even sorrow that is unending. The way we grieve is informed by whether we know

love. Since loving lets us let go of so much fear, it also guides our grief. When we lose someone we love, we can grieve without shame. Given that commitment is an important aspect of love, we who love know we must sustain ties in life and death. Our mourning, our letting ourselves grieve over the loss of loved ones is an expression of our commitment, a form of communication and communion. Knowing this and possessing the courage to claim our grief as an expression of love's passion does not make the process simple in a culture that would deny us the emotional alchemy of grief. Much of our cultural suspicion of intense grief is rooted in the fear that the unleashing of such passion will overtake us and keep us from life. However, this fear is usually misguided. In its deepest sense, grief is a burning of the heart, an intense heat that gives us solace and release. When we deny the full expression of our grief, it lays like a weight on our hearts, causing emotional pain and physical ailments. Grief is most often unrelenting when individuals are not reconciled to the reality of loss.

Love invites us to grieve for the dead as ritual of mourning and as celebration. As we speak our hearts in mourning we share our intimate knowledge of the dead, of who they were and how they lived. We honor their presence by naming the legacies they leave us. We need not contain grief when we use it as a means to intensify our love for the dead and dying, for those who remain alive.

Toward the end of her brilliant career, Kübler-Ross was convinced that there really is no death, only a leaving of the body to take another form. Like those who believe in an afterlife, resurrection, or reincarnation, death becomes, then, not an end, but a new beginning. These insights, however enlightening, do not change the fact that in death we surrender our embodied life on earth. Love is the only force that allows us to hold one another close beyond the grave. That is why knowing how to love each other is also a way of knowing how to die. When the poet Elizabeth Barrett Browning declares in her sonnet "I shall but love thee better after death," she attests to the importance of memory and communion with our dead.

When we allow our dead to be forgotten, we fall prey to the notion that the end of embodied life corresponds to the death of the spirit. In biblical scripture the divine voice declares "I have set before you life and death, therefore choose life." Embracing the spirit that lives beyond the body is one way to choose life. We embrace that spirit through rituals of remembering, through ceremonies wherein we invoke the spirit presence of our dead, and through ordinary rituals in everyday life where we keep the spirit of those we have lost close. Sometimes we invoke the dead by allowing wisdom they have shared to guide our present actions. Or we invoke

through reenacting one of their habits of being. And the grief that may never leave us even as we do not allow it to overwhelm us is also a way to give homage to our dead, to hold them.

In a culture like ours, where few of us seek to know perfect love, grief is often overshadowed by regret. We regret things left unsaid, things left unreconciled. Now and then when I find myself forgetting to celebrate life, un-mindful of the way embracing death can heighten and en-hance the way I interact with the world, I take time to think about whether I would be at peace knowing that I left someone without saying what's in my heart, that I left with harsh words. I try daily to learn to leave folks as though we might never be meeting again. This practice makes us change how we talk and interact. It is a way to live consciously.

The only way to live that life where, as Edith Piaf sings, we "regret nothing" is by awakening to an awareness of the value of right livelihood and right action. Understand-ing that death is always with us can serve as the faithful reminder that the time to do what we feel called to do is always now and not in some distant and unimagined fu-ture. Buddhist monk Thich Nhat Hanh teaches in *Our Appointment with Life* that we find our true selves by living fully in the present: "To return to the present is to be in contact with life. Life can be found only in the pres-

ent moment, because 'the past no longer is' and 'the future has not yet come'. . . . Our appointment with life is in the present moment. The place of our appointment is right here, in this very place." Living in a culture that is always encouraging us to plan for the future, it is no easy task to develop the capacity "to be here now."

When we live fully in the present, when we acknowledge that death is always with us and not just there at the moment when we breathe our last breath, we are not devastated by events over which we have no control—losing a job, rejection by someone we hoped to connect with, the loss of a longtime friend or companion. Thich Nhat Hanh reminds us "everything we seek can only be found in the present" that "to abandon the present in order to look for things in the future is to throw away the substance and hold onto the shadow." To be here now does not mean that we do not make plans but that we learn to give the making of future plans only a small amount of energy. And once future plans are made, we release our attachment to them. Sometimes it helps to write down our plans for the future and put them away, out of sight and out of mind.

Accepting death with love means we embrace the reality of the unexpected, of experiences over which we have no control. Love empowers us to surrender. We do not need to have endless anxiety and worry about whether we will

fulfill our goals or plans. Death is always there to remind us that our plans are transitory. By learning to love, we learn to accept change. Without change, we cannot grow. Our will to grow in spirit and truth is how we stand before life and death, ready to choose life.

Twelve

HEALING:

REDEMPTIVE LOVE

We have been brought into the inner wine cellar and sealed with His seal, which is to suffer out of love. The ardor of this love greatly outweighs any suffering we may undergo, for suffering comes to an end, but love is forever.

—TESSA BIELECKI

LOVE HEALS. WHEN we are wounded in the place where we would know love, it is difficult to imagine that love really has the power to change everything. No matter what has happened in our past, when we open our hearts to love we can live as if born again, not forgetting the past but seeing it in a new way, letting it live inside us in a new way. We go forward with the fresh insight that the past can no longer hurt us. Or if our past was one in which we were loved, we know that no matter the occasional presence of suffering in our lives we will return always to remembered calm and bliss. Mindful remembering lets us put the broken bits and pieces of our hearts together again. This is the way healing begins.

Contrary to what we may have been taught to think, unnecessary and unchosen suffering wounds us but need not scar us for life. It does mark us. What we allow the mark of our suffering to become is in our own hands. In

his collection of essays *The Fire Next Time,* James Baldwin writes about suffering in the healing process, stating: "I do not mean to be sentimental about suffering—but people who cannot suffer can never grow up, can never discover who they are." Growing up is, at heart, the process of learning to take responsibility for whatever happens in your life. To choose growth is to embrace a love that heals.

The healing power of mind and heart is always present because we have the capacity to renew our spirits endlessly, to restore the soul. I am always particularly grateful to meet people who do not feel their childhoods were marked by unnecessary pain and suffering, by lovelessness. Their presence reminds me that we do not need to undergo anything dreadful to feel deeply, that we never need suffering to be imposed upon us by acts of violence and abuse. At times we will all be confronted with suffering, an unexpected illness, a loss. That pain will come whether we choose it or not and not one of us can escape it. The presence of pain in our lives is not an indicator of dysfunction. Not all families are dysfunctional. And while it has been crucial for collective self-recovery that we have exposed and continue to expose dysfunction, it is equally important to revel in and celebrate its absence.

Unless we can all imagine a world in which the family is not dysfunctional but is instead a place where love abounds, we doom family life to be always and only a site

of woundedness. In functional families individuals face conflict, contradictions, times of unhappiness, and suffering just like dysfunctional families do; the difference lies in how these issues are confronted and resolved, in how everyone copes in moments of crisis. Healthy families resolve conflict without coercion, shaming, or violence. When we collectively move our culture in the direction of love, we may see these loving families represented more in the mass media. They will become more visible in all walks of daily life. Hopefully, we will then listen to these stories with the same intensity that we have when we listen to narratives of violent pain and abuse. When this happens, the visible happiness of functional families will become part of our collective consciousness.

In *The Family: A Revolutionary Way of Self-Discovery,* John Bradshaw offers this definition: "A functional healthy family is one in which all the members are fully functional and all the relationships between the members are fully functional. As human beings, all family members have available to them the use of all their human power. They use these powers to cooperate, individuate and to get their collective and individual needs met. A functional family is the healthy soil out of which individuals can become mature human beings." In the functional family self-esteem is learned and there is a balance between autonomy and dependency.

Long before the terms "functional" and "dysfunc-

tional" were used to identify types of families, those of us who were wounded in childhood knew it because we were in pain. And that pain did not go away even when we left home. More than our pain, our self-destructive, self-betraying behavior trapped us in the traumas of childhood. We were unable to find solace or release. We could not choose healing because we were not sure we could ever mend, that the broken bits and pieces could ever be put together again. We comforted ourselves by acting out. But this comfort did not last. It was usually followed by depression and overwhelming grief. We longed to be rescued because we did not know how to save ourselves. More often than not we became addicted to living dangerously. Clinging to this addiction made it impossible for us to be well in our souls. As with all other addiction, letting go and choosing wellness was our only way of rescue and recovery.

In many ways I have acted out throughout much of my life. When I began to walk on the path of love, I was awed by how quickly previous dysfunctions were changed. In the church of my girlhood we were always told no one could give an individual salvation, that we had to choose it for ourselves. We had to want to be saved. In Toni Cade Bambara's novel *The Salt Eaters,* wise older women who are healers are called in to assist the young woman who has attempted suicide, and they tell her: "Just so's you're sure, sweetheart, and ready to be healed, 'cause wholeness

is no trifling matter—a lot of weight when you are well." Making the primal choice to be saved does not mean we do not need support and help with problems and difficulties. It is simply that the initial gesture of taking responsibility for our well-being, wherein we confess to our brokenness, our woundedness, and open ourselves to salvation, must be made by the individual. This act of opening the heart enables us to receive the healing offered us by those who care.

ALTHOUGH WE ALL want to know love, we talk about the search for true love as though it is always and only a solitary quest. I am disturbed by the weighty emphasis on self in so much New Age writing on the topic, and in our culture as a whole. When I would talk about my yearning for a loving partner, people told me over and over that I did not need anyone else. They would say I did not need a companion and/or a circle of loved ones to feel complete, that I should be complete inside myself. While it is definitely true that inner contentedness and a sense of fulfillment can be there whether or not we commune in love with others, it is equally meaningful to give voice to that longing for communion. Life without communion in love with others would be less fulfilling no matter the extent of one's self-love.

All over the world people live in intimate daily contact with one another. They wash together, eat and sleep to-

gether, face challenges together, share joy and sorrow. The rugged individual who relies on no one else is a figure who can only exist in a culture of domination where a privileged few use more of the world's resources than the many who must daily do without. Worship of individualism has in part led us to the unhealthy culture of narcissism that is so all pervasive in our society.

Western travelers journey to the poorest countries and are astounded by the level of communion between people who, though not materially rich, have full hearts. It is no accident that so many of the spiritual teachers we gravitate to in our affluent society, which is driven by the ethos of rugged individualism, come from cultures that value interdependency and working for a collective good over independence and individual gain.

While terms like "codependency," which came out of programs for individual self-recovery, rightly show the ways in which excessive dependency can be unhealthy, especially when it is marked by the support of addictive behavior, we still need to talk about healthy *interdependency*. No organization dedicated to healing demonstrates this principle more than Alcoholics Anonymous. The millions of people who attend AA meetings seek a place of recovery and find that the affirming community that surrounds them creates an environment of healing. This community offers to individuals, some for the first time ever in their lives, a taste of that acceptance, care, knowledge,

and responsibility that is love in action. Rarely, if ever, are any of us healed in isolation. Healing is an act of communion.

Most of us find that space of healing communion with like-minded souls. Other individuals recover themselves in their communion with divine spirit. Saint Teresa of Avila found, in her union with the divine, recognition, comfort, and solace. She wrote: "There is no need to go to heaven in order to speak with one's Eternal Father or find delight in Him. Nor is there any need to shout. However softly we speak, He is near enough to hear us. . . . All one need do is go into solitude and look at Him within oneself, and not turn away from so good a Guest but with great humility speak to Him . . ." Prayer provides a space where talking cures. It is no doubt a sign of the spiritual crisis of our times that books are written to provide proof that prayer is soothing for the soul. All religious traditions acknowledge that there is comfort in reaching for the sacred through words, whether traditional liturgy, prayer, or chants. I pray daily as a gesture of spiritual vigilance. Prayer is an exercise that strengthens the soul's power. Reaching for the divine always reminds me of the limitations of human thought and will. Stretching, reaching toward that which is limitless and without boundaries is an exercise that strengthens my faith and empowers my soul.

Prayer allows each person a private place of confession. There is truth in the axiom "confession is good for the

soul." It allows us to bear witness to our own trespasses, to those ways we miss the mark (a definition of the meaning of sinfulness). It is only as we recognize and confront the circumstances of our spiritual forgetfulness that we assume accountability. In their work *The Raft Is Not the Shore,* Daniel Berrigan and Thich Nhat Hanh stress that "the bridge of illusion must be destroyed before a real bridge can be constructed." In communion with divine spirit we can claim the space of accountability and renew our commitment to that transformation of spirit that opens the heart and prepares us to love.

After we have made the choice to be healed in love, faith that transformation will come gives us the peace of mind and heart that is necessary when the soul seeks revolution. It is difficult to wait. No doubt that is why biblical scriptures urge the seeker to learn how to wait, for waiting renews our strength. When we surrender to the "wait" we allow changes to emerge within us without anticipation or struggle. When we do this we are stepping out, on faith. In Buddhist terms this practice of surrender, of letting go, makes it possible for us to enter a space of compassion where we can feel sympathy for ourselves and others. That compassion awakens us to the healing power of service.

Love in action is always about service, what we do to enhance spiritual growth. A focus on individual reflection, contemplation, and therapeutic dialogue is vital to healing. But it is not the only way to recover ourselves. Serving

others is as fruitful a path to the heart as any other thera-
peutic practice. To truly serve, we must always empty the
ego so that space can exist for us to recognize the needs
of others and be capable of fulfilling them. The greater
our compassion the more aware we are of ways to extend
ourselves to others that make healing possible.

To know compassion fully is to engage in a process of
forgiveness and recognition that enables us to release all
the baggage we carry that serves as a barrier to healing.
Compassion opens the way for individuals to feel empathy
for others without judgment. Judging others increases our
alienation. When we judge we are less able to forgive. The
absence of forgiveness keeps us mired in shame. Often,
our spirits have been broken again and again through ritu-
als of disregard in which we were shamed by others or
shamed ourselves. Shame breaks and weakens us, keeping
us away from the wholeness healing offers. When we prac-
tice forgiveness, we let go of shame. Embedded in our
shame is always a sense of being unworthy. It separates.
Compassion and forgiveness reconnect us.

Forgiveness not only enables us to overcome estrange-
ment, it intensifies our capacity for affirming one another.
Without conscious forgiveness there can be no genuine
reconciliation. Making amends both to ourselves and to
others is the gift compassion and forgiveness offers us. It
is a process of emptying out wherein we let go all the
waste so that there is a clear place within where we can

see the other as ourself. Casarjian explains in *Forgiveness*: "Even small acts of forgiveness always have significant ramifications at a personal level. Even small acts of forgiveness contribute to one's sense of trust in oneself and the potential of others; they contribute to a human spirit that is fundamentally hopeful and optimistic rather than pessimistic or defeated; they contribute to knowing oneself and others as potentially powerful people who can choose to lovingly create, versus seeing humans as basically selfish, destructive and sinners."

When we have clarity of mind and heart we are able to know delight, to engage the sensual world around us with a pleasure that is immediate and profound. In his essay "Down at the Cross," James Baldwin declares: "To be sensual . . . is to respect and rejoice in the force of life, of life itself, and to be present in all that one does, from the effort of loving to the breaking of bread." Poet Adrienne Rich cautions against the loss of the sensual in *What Is Found There? Notebooks on Poetry and Politics*: "Sensual vitality is essential to the struggle for life. It's as simple— and as threatened—as that." Estrangement from the realm of the senses is a direct product of overindulgence, of acquiring too much. This is why living simply is a crucial part of healing. As we begin to simplify, to let the clutter go, whether it is the clutter of desire or the actual material clutter and incessant busyness that fills every space, we recover our capacity to be sensual. When the asleep body,

numb and deadened to the world of the senses, awakens, it is a resurrection that reveals to us that love is stronger than death.

LOVE REDEEMS. DESPITE all the lovelessness that surrounds us, nothing has been able to block our longing for love, the intensity of our yearning. The understanding that love redeems appears to be a resilient aspect of the heart's knowledge. The healing power of redemptive love lures us and calls us toward the possibility of healing. We cannot account for the presence of the heart's knowledge. Like all great mysteries, we are all mysteriously called to love no matter the conditions of our lives, the degree of our depravity or despair. The persistence of this call gives us reason to hope. Without hope, we cannot return to love. Breaking our sense of isolation and opening up the window of opportunity, hope provides us with a reason to go forward. It is a practice of positive thinking. Being positive, living in a permanent state of hopefulness, renews the spirit. Renewing our faith in love's promise, hope is our covenant.

I began thinking and writing about love when I heard cynicism instead of hope in the voices of young and old. Cynicism is the greatest barrier to love. It is rooted in doubt and despair. Fear intensifies our doubt. It paralyzes. Faith and hope allow us to let fear go. Fear stands in the way of love. When we take to heart the biblical insistence

that "there is no fear in love," we understand the necessity of choosing courageous thought and action. This scripture encourages us to find comfort in knowing that "perfect love casts our fear." This is our reminder that even if fear exists it can be released by the experience of perfect love. The alchemy of perfect love is such that it offers to us all a love that is able to vanquish fear. That which is rendered separate or strange through fear is made whole through perfect love. It is this perfect love that is redemptive—that can, like the intense heat of alchemical fire, burn away impurities and leave the soul free.

Significantly, we are told in biblical scripture that it is crucial that love casts out fear "because fear hath torment." These words speak directly to the presence of anguish in our lives when we are driven by fear. The practice of loving is the healing force that brings sustained peace. It is the practice of love that transforms. As one gives and receives love, fear is let go. As we live the understanding that "there is no fear in love" our anguish diminishes and we garner the strength to enter more deeply into love's paradise. When we are able to accept that giving ourselves over to love completely restores the soul, we are made perfect in love.

The transformative power of love is not fully embraced in our society because we often wrongly believe that torment and anguish are our "natural" condition. This assumption seems to be affirmed by the ongoing tragedy that

prevails in modern society. In a world anguished by rampant destruction, fear prevails. When we love, we no longer allow our hearts to be held captive by fear. The desire to be powerful is rooted in the intensity of fear. Power gives us the illusion of having triumphed over fear, over our need for love.

To return to love, to know perfect love, we surrender the will to power. It is this revelation that makes the scriptures on perfect love so prophetic and revolutionary for our times. We cannot know love if we remain unable to surrender our attachment to power, if any feeling of vulnerability strikes terror in our hearts. Lovelessness torments.

As our cultural awareness of the ways we are seduced away from love, away from the knowledge that love heals gains recognition, our anguish intensifies. But so does our yearning. The space of our lack is also the space of possibility. As we yearn, we make ourselves ready to receive the love that is coming to us, as gift, as promise, as earthly paradise.

Thirteen

DESTINY:
WHEN ANGELS SPEAK OF LOVE

Love is our true destiny. We do not find the meaning
of life by ourselves alone—we find it with another.

— THOMAS MERTON

BELIEVING IN DIVINE love comforted me as a child when I felt overwhelmed by loneliness and sorrow. The solace of knowing I could speak my heart to God and the angels made me feel less alone. They were there with me during anguished and terrifying dark nights of the soul when no one understood. They were there with me, listening to my tears and my heartache. I could not see them but I knew they were there. I heard them whispering to me about love's promise, letting me know all would be well with my soul, speaking to my heart in a divinely sweet secret language.

Angels bear witness. They are the guardian spirits who watch, protect, and guide us throughout our lives. Sometimes they take a human form. At other times they are pure spirit—unseen, unimaginable, just forever present. One sign that a religious awakening is taking place in our culture is our obsession with angels. Images of angels are

everywhere; they are characters in movies, images in books, on notecards and calendars, on curtains and wallpaper. Angels represent for us a vision of innocence, of beings not burdened by guilt or shame. Whether we imagine them the dark round-faced forms of Coptic tradition or the fair, winged cherubs that we usually see, they are messengers of the divine. We see them as always bringing news that will give our hearts ease.

Our cultural passion for the angelic expresses our longing to be in paradise, to return on earth to a time of connectedness and goodwill, to a time when we were heart-whole. Even though the images of angels we most commonly see are childlike figures aglow with rapture and unspeakable delight, as messengers they carry the weight of our burdens, our sorrows, and our joys. In representations they are most often given a childlike visage to remind us that enlightenment comes only as we return to a childlike state and are born again.

We see angels as light-hearted creatures in swift motion reaching for the heavens. Their being and the weight of their knowledge is never static. Always changing, they see through our false selves. Possessing psychic insight, intuition, and the wisdom of the heart they stand for the promise of life fulfilled through the union of knowledge and responsibility. As guardians of the soul's well-being, they care for us and with us. Our turning toward the an-

gelic is evocative of our yearning to embrace spiritual growth. It reveals our collective desire to return to love.

THE FIRST STORIES of angels I heard as a child were told at church. From religious teachings I learned that as messengers of the divine, angels were wise counselors. They were able to assist us in our spiritual growth. Unconditional lovers of the human spirit, they were there to help us face reality without fear. The story of an angel that remained most vivid to me throughout my childhood and on into my adult life was the narrative of Jacob's confrontation with the angel on his way home. Jacob was not just any old biblical hero, he was a man capable of intense passionate love. Coming out of the wilderness, where as a young man he fled from familial strife, Jacob enters the land where his relatives live. He meets there his soul mate, Rachel. Even though he swiftly acknowledges his love for her, they can unite only after much hard work, struggle, and suffering.

We are told Jacob served seven years for Rachel, but it seemed to him only a few days "so great was the love he had to her." Interpreting this story in *The Man Who Wrestled with God,* John Sanford comments: "The fact that Jacob could fall in love at all shows that a certain amount of psychological growth had taken place in him during his journey through the wilderness. So far the only

woman in his life had been his mother. As long as a man remains in a state of psychological development in which his mother is the most important woman to him, he cannot mature as a man. A man's eros, his capacity for love and relatedness, must be freed from attachment to the mother, and able to reach out to a woman who is his contemporary; otherwise he remains a demanding, dependent, childish person." Here Sanford is speaking about negative dependency, which is not the same as healthy attachment. Men who are positively attached to their mothers are able to balance that bond, negotiating dependency and autonomy, and can extend it to affectional bonds with other women. In fact, most women know that a man who genuinely loves his mother is likely to be a better friend, partner, or mate than a man who has always been overly dependent on his mother, expecting her to unconditionally meet all his needs. Since genuine love requires a recognition of the autonomy of ourselves and the other person, a man who has loved in childhood has already learned healthy practices of individuation. As Jacob labors for Rachel, making wrong choices and difficult decisions, he grows and matures. By the time they wed he is able to be a loving partner.

Meeting his soul mate does not mean Jacob's journey toward self-actualization and wholeness ends. When he receives the message from God that he should return to the home he once ran from, he must once again journey

through the wilderness. Again and again wise spiritual teachers share with us the understanding that the journey toward self-actualization and spiritual growth is an arduous one, full of challenges. Usually it is downright difficult. Many of us believe our difficulties will end when we find a soul mate. Love does not lead to an end to difficulties, it provides us with the means to cope with our difficulties in ways that enhance our growth. Having worked and waited for love, Jacob becomes psychologically strong. He calls upon that strength when he must once again enter the wilderness to journey home.

A divine voice brings Jacob the message that he must return to the land of his ancestors. As a man who has learned to love, Jacob intuitively asks for guidance. He listens to his heart speak. When the answer comes, he acts. Since he left home in the first place because he had conflicts with his brother Esau, the prospect of returning is frightening. But he must come face to face with his past and seek reconciliation if he is to know inner peace and become fully mature. On the long journey home Jacob continually engages in conversations with God. He prays. He meditates. Seeking solace in solitude he goes in the dead of the night and walks by a stream. There, a being he does not fully recognize wrestles with him. Unbeknownst to him, Jacob has been given the gift of meeting an angel face to face.

Confronting his fears, his demons, his shadow self, Ja-

cob surrenders the longing for safety. Psychologically he enters a primal night and returns to a psychic space where he is not yet fully awake. It is as though he becomes a child in the womb again striving to be reborn. The angel is not an adversary seeking to take his life, but rather comes as a witness enabling him to receive the insight that there is joy in struggle. His fear is replaced by a sense of calm. In *Soul Food: Stories to Nourish the Spirit and the Heart,* Jack Kornfield and Christina Feldman write that we too can choose serenity in the midst of struggle: "In that calmness we begin to understand that peace is not the opposite of challenge and hardship. We understand that the presence of light is not a result of darkness ending. Peace is found not in the absence of challenge but in our own capacity to be with hardship without judgment, prejudice, and resistance. We discover that we have the energy and the faith to heal ourselves, and the world, through an openheartedness in this movement." As Jacob embraces his adversary, he moves through the darkness into the light.

Rather than letting the angel go when light comes, Jacob demands and is given a blessing. Significantly, he cannot receive the blessing without first letting fear go and opening his heart to be touched by grace. Sanford writes: "Jacob refused to part with his experience until he knew its meaning, and this marked him as a man of spiritual greatness. Everyone who wrestles with his spiritual and

psychological experience, and, no matter how dark or frightening it is, refuses to let it go until he discovers its meaning, is having something of the Jacob experience. Such a person can come through his dark struggle to the other side reborn, but one who retreats or runs from his encounter with spiritual reality cannot be transformed." It should reassure us that the blessing the angel gives to Jacob comes in the form of a wound.

Woundedness is not a cause for shame, it is necessary for spiritual growth and awakening. I can remember how strange it seemed to me as a child when I read this story over and over in my big book of Bible stories for children, that to be wounded could be a blessing. To my child's mind woundedness was always negative. Being unable to protect oneself from hurts inflicted by others was a source of shame. In *Coming Out of Shame,* Gershen Kaufman and Lev Raphael contend: "Shame is the most disturbing emotion we ever experience directly about ourselves, for in the moment of shame we feel deeply divided from ourselves. Shame is like a wound made by an unseen hand, in response to defeat, failure or rejection. At the same moment that we feel most disconnected, we long to embrace ourselves once more, to feel reunited. Shame divides us from ourselves, just as it divides us from others, and because we still yearn for reunion, shame is deeply disturbing." Shame about woundness keeps many people from seeking healing. They would rather deny or repress the

reality of hurt. In our culture we hear a lot about guilt but not enough about the politics of shame. As long as we feel shame, we can never believe ourselves worthy of love.

Shame about being hurt often has its origin in childhood. And it is then that many of us first learn that it is a virtue to be silent about pain. In *Banished Knowledge: Facing Childhood Injuries,* psychoanalyst Alice Miller states: "Not to take one's own suffering seriously, to make light of it or even to laugh at it, is considered good manners in our culture. This attitude is even called a virtue and many people (at one time including myself) are proud of their lack of sensitivity toward their own fate and above all toward their own childhood." As more people have found the courage to break through shame and speak about woundedness in their lives, we are now subjected to a mean-spirited cultural response, where all talk of woundedness is mocked. The belittling of anyone's attempt to name a context within which they were wounded, were made a victim, is a form of shaming. It is psychological terrorism. Shaming breaks our hearts.

All individuals who are genuinely seeking well-being within a healing context realize that it is important to that process not to make being a victim a stance of pride or a location from which to simply blame others. We need to speak our shame and our pain courageously in order to recover. Addressing woundedness is not about blaming others; however, it does allow individuals who have been,

and are, hurt to insist on accountability and responsibility both from themselves and from those who were the agents of their suffering as well as those who bore witness. Constructive confrontation aids our healing.

The story of Jacob's confrontation with the angel is a narrative of healing precisely because it shows he is innocent. There is nothing he has done to anger the angel. The adversarial conflict is not of his making. He is not accountable. And he is not to blame for his wound. However, healing happens when he is able to embrace the wound as a blessing and assume responsibility for his actions.

We are all wounded at times. A great many of us remain wounded in the place where we would know love. We carry that wound from childhood into adulthood and on into old age. The story of Jacob reminds us that embracing our wound is the way to heal. He accepts his vulnerability. Kornfield and Feldman remind us that the moment in which we are touched by pain and "the unpredictability of life's changes" is the moment in which we can find salvation: "As we turn toward the specific shadows in our own lives with an open heart and a clear and focused mind, we cease resisting and begin to understand and to heal. In order to do this, we must learn to feel deeply, not so much opening our eyes as opening the inner sense of the mind and the heart." When Jacob wrestles with the angel, he feels a heightened sense of awareness. Facing this

struggle gives him the courage to persevere in his journey back to face conflicts and reconcile them rather than live in alienation and estrangement.

As a nation, we need to gather our collective courage and face that our society's lovelessness is a wound. As we allow ourselves to acknowledge the pain of this wound when it pierces our flesh and we feel in the depths of our soul a profound anguish of spirit, we come face to face with the possibility of conversion, of having a change of heart. In this way, recognition of the wound is a blessing because we are able to tend it, to care for the soul in ways that make us ready to receive the love that is promised.

Angels bring to us the knowledge of how we must journey on the path to love and well-being. Coming to us in both human form and as pure spirit they guide, instruct, and protect. Alice Miller chose to call the angelic force in an individual's life the "enlightened witness." To her, this was, in particular, any individual who offered hope, love, and guidance to a wounded child in any dysfunctional setting. Most folks who come from a conflict-ridden family or a setting that was lacking in love remember the individuals who offered sympathy, understanding, and at times a way out. Speaking of her mother's "miserable childhood" Hillary Clinton remembers that "others outside the family circle stepped in, and their help made all the difference." From childhood on, I found many of my angels in favorite authors, writers who created books that

enabled me to understand life with greater complexity. These works opened my heart to compassion, forgiveness, and understanding. In her memoir *Are You Somebody?*, Irish journalist Nuala O'Faolain writes about the life-saving nature of books, declaring, "If there was nothing else, reading would—obviously—be worth living for."

German poet Rainer Maria Rilke's autobiographical writing transformed my sense of self as a teenager. At a time when I felt like an outsider, unworthy and unwanted, his work gave me a way to see being an outsider as a place of creativity and possibility. In the concluding chapter of the memoir of my girlhood, *Bone Black,* I write: "Rilke gives meaning to the wilderness of spirit I am living in. His book is a world I enter and find myself. He tells me that everything terrible is really something helpless that wants help from us. I read *Letters to a Young Poet* over and over. I am drowning and it is the raft that takes me safely to the shore." I received his book as a gift at a spiritual retreat. There I met a priest who worked as a chaplain at a nearby college. He was one of the featured speakers. Intuiting the depths of my despair, he offered me solace. I was in my teens and had begun to feel as though I could not go on living. Suicidal longings dominated my waking thoughts and my nightmares. I believed death would release me from the overwhelming sadness that weighed me down.

Listening to spiritual testimony at the retreat I felt even

more sorrowful. I could not understand how everyone else could be lifted by divine spirit when I felt more and more alone, as though I was falling into an abyss without hope of rescue. I never asked Father B. what he saw when he looked at me or why I was chosen as one of the individuals he singled out for spiritual counseling. He touched my soul, offering to me (and to everyone he connected with) a loving spirit. In his presence I felt chosen, beloved. Like many earthly angels who visit us and touch our lives with their visionary power and healing wisdom, I never encountered him again. But I have never forgotten his presence, the gifts he offered to me—gifts of love and compassion freely given.

The presence of angels, of angelic spirits, reminds us that there is a realm of mystery that cannot be explained by human intellect or will. We all experience this mystery in our daily lives in some ways, however small, whether we see ourselves as "spiritual" or not. We find ourselves in the right place at the right time, ready and able to receive blessings without knowing just how we got there. Often we look at events retrospectively and can trace a pattern, one that allows us to intuitively recognize the presence of an unseen spirit guiding and directing our path.

When I was a young girl, I would lie in my attic bed and talk endlessly with divine spirit about the nature of love. Then, I did not imagine I would ever have the cour-

age to speak about love without the solitary covering of secrecy or night. Like Jacob, wandering alone by the stream, in the stillness of my pitch-dark room I grappled with the metaphysics of love, seeking to understand love's mystery. That grappling continued until my awareness intensified and a new vision of love came to me. Now I recognize that I was engaged from then until now in a disciplined spiritual practice—opening the heart. It led me to become a devout seeker on love's path—to talk with angels face to face unafraid.

Understanding all the ways fear stands in the way of our knowing love challenges us. Fearful that believing in love's truths and letting them guide our lives will lead to further betrayal, we hold back from love when our hearts are full of longing. Being loving does not mean we will not be betrayed. Love helps us face betrayal without losing heart. And it renews our spirit so we can love again. No matter how hard or terrible our lot in life, to choose against lovelessness—to choose love—we can listen to the voices of hope that speak to us, that speak to our hearts— the voices of angels. When angels speak of love they tell us it is only by loving that we enter an earthly paradise. They tell us paradise is our home and love our true destiny.

QUOTATIONS ARE REPRINTED FROM

Jack Kornfield, *A Path with Heart,* Shambhala Publications, 1994

Diane Ackerman, *A Natural History of Love,* Random House, 1994

Judith Viorst, *Necessary Losses,* Simon & Schuster, 1986

John Welwood, *Love and Awakening,* HarperCollins, 1996

M. Scott Peck, *The Road Less Traveled,* Simon & Schuster, 1978

Tessa Bielecki, *Holy Daring,* Element Inc., 1994

Marianne Williamson, *The Healing of America,* Simon & Schuster, 1977

Sharon Salzberg, *A Heart As Wide As the World,* Shambhala Publications, 1997

Parker Palmer, *The Active Life,* HarperCollins, 1990

Henri Nouwen, *The Inner Voice of Love,* Doubleday, 1996

Thomas Merton, *Love and Liking,* Commonweal Publishing, 1997

© Marion Etlinger

About the Author

bell hooks is a cultural critic, feminist theorist, and writer. Celebrated as one of our nation's leading public intellectuals by *The Atlantic Monthly,* as well as one of *Utne Reader*'s "100 Visionaries Who Could Change Your Life," she is a charismatic speaker who divides her time among teaching, writing, and lecturing around the world. Previously a professor in the English departments at Yale University and Oberlin College, hooks is the author of more than seventeen books, including *All About Love: New Visions; Remembered Rapture: The Writer at Work; Wounds of Passion: A Writing Life; Bone Black: Memories of Girlhood; Killing Rage: Ending Racism; Art on My Mind: Visual Politics;* and *Breaking Bread: Insurgent Black Intellectual Life.* She lives in New York City.

ALSO BY
bell hooks

COMMUNION
The Female Search for Love

"A powerful guidebook to life." — *Library Journal*

Intimate, revealing, provocative, *Communion* challenges every female to courageously claim the search for love as the heroic journey we must all choose to be truly free. In her trademark commanding and lucid language, hooks explores the ways ideas about women and love were changed by the feminist movement, by women's full participation in the workforce, and by the culture of self-help. *Communion* is the heart-to-heart talk every woman—mother, daughter, friend, and lover—needs to have.

SALVATION
Black People and Love

"A frank and hard-hitting, psychologically astute, and beautifully crafted treatise on the meaning of love and why it's essential to a healthy society."
— *Booklist*

Whether talking about the legacy of slavery, relationships and marriage in Black life, the prose and poetry of our most revered artists and leaders, the liberation movements of the 1950s, '60s, and '70s, or hip-hop and gangsta rap culture, hooks lets us know what love's got to do with it. *Salvation* is work that helps us heal—and shows us how to create beloved American communities.